SECRET
BLACK
COUNTRY

Andrew Homer

AMBERLEY

First published 2022

Amberley Publishing
The Hill, Stroud
Gloucestershire, GL5 4EP

www.amberley-books.com

Copyright © Andrew Homer, 2022

The right of Andrew Homer to be identified as the
Author of this work has been asserted in accordance
with the Copyrights, Designs and Patents Act 1988.

ISBN 978 1 4456 9754 3 (print)
ISBN 978 1 4456 9755 0 (ebook)

British Library Cataloguing in Publication Data.
A catalogue record for this book is available from the
British Library.

Origination by Amberley Publishing.
Printed in Great Britain.

Contents

Introduction

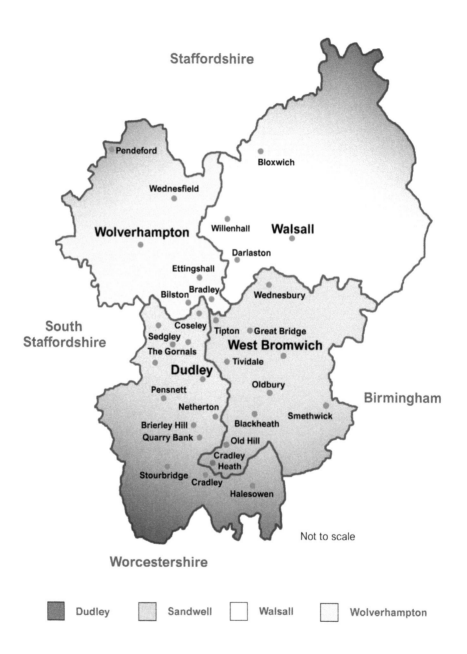

Staffordshire

Pendeford

Bloxwich

Wednesfield

Wolverhampton

Willenhall

Walsall

Darlaston

South
Staffordshire

Ettingshall

Bilston Bradley

Wednesbury

Coseley Tipton Great Bridge
Sedgley
The Gornals West Bromwich

Dudley Tividale

Pensnett Oldbury

Netherton Birmingham

Brierley Hill Blackheath Smethwick
Quarry Bank Old Hill

Cradley
Heath

Stourbridge Cradley

Halesowen

Not to scale

Worcestershire

| | Dudley | | Sandwell | | Walsall | | Wolverhampton |

The Black Country.

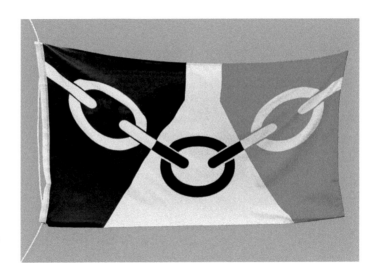

The official regional flag of the Black Country.

Secret Black Country carries on from where *A–Z of the Black Country*, by the same author, left off. An alternative title to this book could well have been, '*I didn't know that*', as there is much to surprise and inform even for those already well versed in the Black Country and its history.

The Black Country is unique in many ways and not the least being where it actually is, as there is no common agreement. This was the reason given by the Ordnance Survey in 2009 when they named the Black Country for the first time but declined to draw a boundary line around it. Indeed, the Black Country could be said to be wherever a Black Country 'mon or wench' says it is. The dialect is yet another unique aspect of the region with its origins in Old English or Anglo-Saxon.

For the purposes of this book the Black Country is defined as the area constrained by the four metropolitan boroughs of Dudley, Walsall, Sandwell and Wolverhampton. Not everyone will agree. Wolverhampton is a good case in point but miss it out and the amazing true story behind the film *The Aeronauts* could not be told. Neither could the story of the Battle of Britain's now mainly forgotten fighter or the world's fastest slug!

Even the very name, Black Country, is open to debate. Some will say it was the abundance of coal, including the famous 30-foot seam nicknamed 'the thick'. On early geological maps the South Staffordshire Coal Seam would be shaded grey or black. Others will say it was the continuous pall of black smoke that polluted the whole area. This was famously described by the American Consul to Birmingham, Elihu Burritt, as 'black by day and red by night' in his 1869 book *Walks in The Black Country and its Green Border-land*. Black by day because of all the smoke and pollution and red by night because of the reflected glow from all the forges and furnaces.

The fact that the area was black did not go unnoticed by the future Queen Victoria in a much-misquoted story that it was she who named the Black Country. Discover the real story within these pages. It was largely due to the efforts of the Black Country Society, founded in 1967, that the name did not simply disappear. The society is still thriving and so too is its quarterly magazine, *The Blackcountryman*.

The Black Country has its own officially registered regional flag designed by schoolgirl Gracie Sheppard for a competition in 2012. The flag really captured the industrial heritage of this area and can be seen flying all over the Black Country including from civic buildings. It represents the industrial heritage of the region through the depiction of chain and the Redhouse Glass Cone. The striking red and black colour scheme takes inspiration from Elihu Burritt's famous quote but has not escaped criticism due to chain being an unintentional link to slavery. Ironically, Elihu Burritt himself was a committed pacifist who detested slavery and had unsuccessfully advocated for its abolition in America prior to the Civil War which finally ended it.

Chain and anchor making were important industries in the Black Country with the most famous examples being the anchors and chains for RMS *Titanic* and *Olympic*. The huge centre anchor for the *Titanic* famously needed to be hauled by twenty heavy horses – or did it? Read the book to find out!

DID YOU KNOW?
Charles Dickens was familiar with the Black Country. In his novel *The Old Curiosity Shop*, published in 1841, he described how the industry and factories of the region 'poured out their plague of smoke, obscured the light, and made foul the melancholy air'. In a letter to his sister-in-law Georgina Hogarth from Wolverhampton in November 1858 Dickens wrote that, 'We came through a part of the Black Country that you know, and it looked at its blackest. All the furnaces seemed in full blast, and all the coal-pits to be working'.

1. Echoes from the Past

Sleipnir

Rearing up over Wednesbury and overlooking the Midland Metro Line 1 is a massive 18-foot stainless steel sculpture of an eight-legged horse. Many Metro passengers seeing this structure must wonder what the significance of an eight-legged horse is to the town of Wednesbury. The horse is Sleipnir, designed by artist Steve Field, and commissioned by the Altram Consortium, who built the Midland Metro. The complex construction was in the skilled hands of father and son team Ralph and Ralph Flavell of Brierley Hill based Apollo Fabrications. When Princess Anne formally opened the new Metro tram service in September 1999, she also got to see Sleipnir. As an accomplished rider, how appropriate that she should be presented with a miniature silver statue of the horse crafted in Birmingham's Jewellery Quarter by Nick Adams.

Sleipnir goes right back to the origins of the name Wednesbury itself. When the Anglo-Saxons arrived after the Romans, they brought with them their own Germanic gods. One of these was Woden, who would have been recognised by the Vikings as the Norse god Odin. Odin rode a magical eight-legged horse, Sleipnir, who could gallop across land, sea and through the air. Wednesbury takes its name from Woden and in the 1086 Domesday Book the settlement was known as 'Wadnesberie', meaning 'Woden's Fortification'.

With the new Wednesbury to Brierley Hill Metro extension Sleipnir is going to be much more visible on its prominent hillside position. The new line will branch off the existing line near Wednesbury's Great Western Street Metro stop and trams will run right past

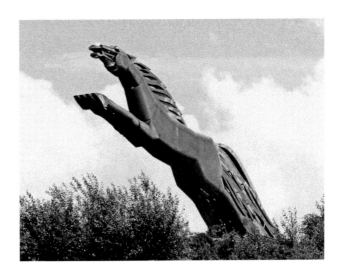

Sleipnir. (Courtesy of Tony Hisgett)

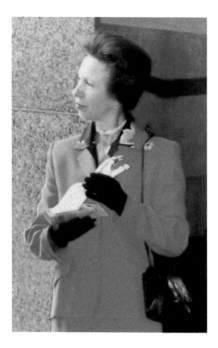

Princess Anne receiving a miniature silver statue of Sleipnir. (Courtesy of Steve Field)

Sleipnir. Over the years trees and undergrowth have partially obscured the sculpture. With the opening of the new Metro line, it would be the perfect opportunity to thin out the vegetation and perhaps even add night-time illumination to reveal Sleipnir in his full glory as originally intended. Steve Field's vision for Sleipnir is as relevant today as when the Metro first opened. Sleipnir is representative of the area, 'making a leap from the past into the future'.

DID YOU KNOW?
Place names and artwork in Wednesbury commemorate a Mercian warrior princess known as the Lady of the Mercians. Aethelflaed (also known as Ethelfleda) was the daughter of King Alfred the Great and sister to Edward the Elder. Legend has it that Ethelfleda fortified what is now Church Hill against the Danes. Together with Edward, their Anglo-Saxon armies won a decisive battle against the Vikings at Tettenhall (or possibly Wednesfield) in the year 910.

Lost Medieval Village

Long before the Industrial Revolution, Halesowen was a place of pilgrimage to the now lost medieval village of Kenelmstowe. With its small Norman church, which replaced an earlier chapel, Kenelmstowe grew out of the legend of St Kenelm. The legend tells how the seven-year-old Kenelm (Cynehelm) becomes King of Mercia c. 819. His jealous sister had

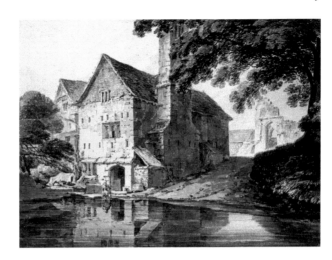

The Ruins of the Monastery at Halesowen. (Photo by Birmingham Museums Trust, licensed under CCo)

St Kenelm's Church and site of the Holy Well.

him murdered in the Client Hills and his body buried under a tree in an attempt to seize power herself. After his murder, Kenelm transforms into a dove and flies to Rome with a scroll to inform the Pope where his body is buried. The Pope despatches missionaries who find the burial place of Kenelm guarded over by a cow who needs no food or drink. When Kenelm's body is removed from the grave a spring appears, creating a holy well. Such is the legend, but what little history there is shows that Kenelm never was a king and most likely died in his mid-twenties, possibly fighting the Welsh.

In the medieval world this was big business. Nearby Halesowen Abbey and the village would profit from pilgrims seeking forgiveness for sins and cures for ailments at the shrine of St Kenelm in the undercroft of the small church, and from the waters of the sacred spring. In 1253 Roger de Somery, the lord of Dudley, obtained permission from King Henry III to hold an annual four-day fair around St Kenelm's day, 17 July. The fair was held near the chapel and would have been a significant event for Kenelmstowe.

Everything was to change in 1349 with the arrival of the Black Death. Surviving manorial rolls from Halesowen Abbey paint a grim picture, which would be repeated throughout the Black Country. Halesowen was severely affected between May and August of 1349 and the records show that approximately 40 per cent of male tenants died. This does not seem to have led to the total demise of Kenelmstowe though. The village had its own inn called the Red Cow, a reference to the cow who guarded Kenelm's grave, and as late as 1499 records show a £5 rental still being paid.

According to Bishop Lyttelton, writing in his 'History of Hagley' around 1736, it was diverting the high road from Bromsgrove to Dudley that killed the village. Yet it was pilgrimage that had brought people to Kenelmstowe since Saxon times, not passing trade. John Noakes, in his 1848 book *The Rambler in Worcestershire*, makes another suggestion that Hugh Latimer, Bishop of Worcester, from 1535 to 1539, with his 'discouragement put upon pilgrimages' had 'considerable effect in reducing the importance of the place'. The final death knell for Kenelmstowe as a pilgrimage destination most likely coincided with the dissolution of Halesowen Abbey in 1538. Nowadays, just a field remains where the village once thrived, but visitors still leave offerings at St Kenelm's Sacred Spring.

Saving St Chad

The rediscovery of the bones of St Chad or Ceadda is a remarkable story but just how did the relics of a Northumbrian-born saint come to be secreted away in the Black Country? One of four brothers who all became priests, Chad studied under St Aiden in the monastery of Lindisfarne. Chad became the Abbot of Lastingham in Yorkshire on the death of his elder brother St Cedd. Chad's connection with this area began in 669 when the Christian king of the Mercians, Wulfhere, provided land at Lichfield and appointed Chad as Bishop of Mercia. After his untimely death from the plague in 672, the 'holy man of modest character', as Bede described him, was immediately venerated as a saint. The Shrine of Saint Chad made Lichfield Cathedral a major centre of medieval pilgrimage.

In 1538 Lichfield Cathedral suffered the consequences of Henry VIII's Reformation. Fearing the Shrine of St Chad would be destroyed, Prebendary Arthur Dudley bravely smuggled some of the relics out of the cathedral. By the time he died in 1577 the relics had been passed to his nieces, Bridget and Katherine Dudley, of Russells Hall Dudley. Fearful for their own safety, the relics were passed on to William and Henry Hodgetts of Flaxhalls, later renamed High Arcal, at Woodsetton in Sedgley. After William died in 1649, Henry continued to keep the secret until he confided to Jesuit Friar Peter Taylor on his deathbed in 1651. Henry was fervently praying to St Chad and when asked why by the friar revealed that the relics were hidden above his four-poster bed. Peter Taylor's own written testament in 1652 confirms that he was next to take on the responsibility. Following Turner's death in 1665 the relics were on the move again. Firstly, to John Leveson of Willenhall where they were almost destroyed by soldiers during a search, and then to a seminary at St Omer in France. In the early nineteenth century, they found their way to Aston Hall near Stone, the home of Sir Thomas Fitzherbert-Brockholes. After his death, the relics were rediscovered in the chapel and presented to Bishop Thomas Walsh in 1837. When Birmingham St Chad's Cathedral was consecrated in 1841, the relics were placed in a new shrine designed by architect Augustus Pugin.

The Cathedral Church of
St Chad in Birmingham.

After such a tortuous journey what were the chances that these really were the bones of
St Chad? To answer this question the relics were examined by the University of Oxford
Archaeology Unit. They concluded that the bones were from more than one person, but
at least some of them were seventh century and could well be the much-travelled relics of
St Chad.

From Brew'us to Beerhouse

Why should many of the Black Country's older drinking establishments resemble private
dwellings rather than purpose-built public houses? The answer goes back to 1830 and
Wellington's Beerhouse Act, known colloquially as the 'Beer Act'. This enabled anyone
with 2 guineas to legally sell beer and cider from their own home, shop, or business
without recourse to the local magistrates. The Act was partly intended to curtail the
activities of big London brewers and their associated tied houses selling poor-quality
products, while also encouraging free trade by removing the duty from beer.

Within the first ten years of the Act there were over 1,500 new beerhouses listed in
the Parliamentary returns for the Stourbridge Excise Collection, which covered the Black
Country. Percentage wise this was a far greater take up than either London or the country
as a whole. Furthermore, unlike the rest of the country virtually all of the Black Country
beerhouse keepers, and established licenced victuallers for that matter, were brewing
their own beer rather than relying heavily on commercial breweries as was the case
in London.

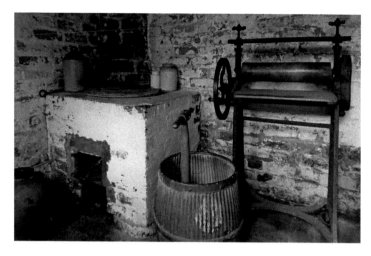

A typical domestic brewhouse or 'brew-us'. (Courtesy of the Black Country Living Museum)

The Brittania Inn, Upper Gornal. Typical home brew pub which was also a butcher's shop.

The Black Country already had a strong tradition of domestic brewing in the brewhouse, known locally as the 'brew-us', where the copper would be used for boiling dirty whites on wash day and also the wort for home-brewed beer. There was a wealth of brewing experience in the Black Country, and it is easy to see why a 2 guinea licence to establish a beerhouse would be an attractive proposition for many people. It was quite common for a wife to run the beerhouse for extra income while her husband carried on his normal trade.

As well as legitimate beerhouses, many others became synonymous with crime, prostitution and widespread drunkenness. It all came to an end with the Wine and Beerhouse Act of 1869, which placed responsibility for licenses firmly back in the hands of the magistrates. No new beerhouse licenses were issued, and disorderly establishments were promptly shut down. Some beerhouse keepers became licensed victuallers but

many more beerhouses were bought up by the big breweries such as Wolverhampton and Dudley Breweries, and run as tied houses. The very thing the 1830 Beer Act had sought to avoid, and one of the reasons why real ale almost, but thankfully not quite, lost out to pasteurised keg beer in the 1970s.

DID YOU KNOW?
There have been some notable women involved in Black Country brewing. Julia Hanson & Sons Ltd can be traced back to 1847 when she and her husband founded a wines and spirits business in Priory Street, Dudley. It would go on to become the only major brewery in the country to have a lady's name. Other famous brewery women of the Black Country include Sarah Hughes of the Sedgley Beacon Hotel's Sarah Hughes Brewery and the famous 'Ma' Pardoe of the Old Swan in Netherton.

Ballad of Bandy Leg Lett

This is to gi' notice,
That Bandy Leg Lett,
Will sell his wife, Sally,
For what he con get.

So went the first verse of a popular local ballad describing a custom practised in the Black Country as it was elsewhere. That was wife-selling. There was more to it than just harsh treatment of women though. It concerned the laws around divorce or lack of them especially for poorer folk. Prior to the Matrimonial Causes Act of 1857, the only way to obtain a legal divorce was by a Private Act of Parliament. Providing a certain ritual was followed, the 'divorce' obtained through wife-selling, although illegal, would still be considered socially acceptable.

The *Wolverhampton Chronicle* reported on a wife-sale that took place at Walsall Market on 17 October 1837. Despite describing the event as a 'strange and unwonted exhibition' it nevertheless provides a contemporary description of the custom. George Hitchinson led his wife through a 'turnpike gate' by a halter attached around her neck and waist. A toll ticket was often used as proof of 'ownership' and transferred to the purchaser. She was sold in the market to a nailer called Thomas Snape, for the sum of 2s 6d in front of assembled witnesses. Everyone was satisfied with the arrangement, especially Hitchinson's wife it seems, as she had apparently been living with Snape for the previous three years! The price was normally agreed with the purchaser beforehand, and although the separation was illegal, it generally suited all parties. After the sale it was common practice to hold a celebration in any convenient public house.

In a wife-sale reported at Wednesbury, other aspects of the custom are described when Moses 'Maggs' Whitehouse, also known locally as Rough Moey, sold his much younger

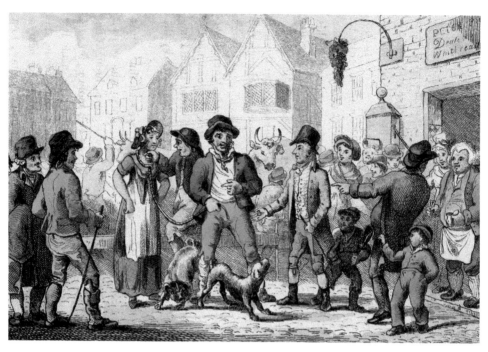

Wife-selling in 1816. (Contributor: Alamy Stock Photos)

wife Sally along with her baby. A bellman (town crier) publicised the event beforehand. Rough Moey, described as having only one good eye and one good leg after a pit explosion, acted as the auctioneer himself. Despite a speculative bid of eighteen pennies from someone in the good-natured crowd, the agreed purchaser was a young collier named Jack, who offered 2s 6d, and after some bargaining 'three gallons o' drink [ale]' much to everyone's satisfaction. Hopefully, Sally was happier with her young collier and it was reported that she was 'evidently in her best attire ... no doubt in honour of the occasion'.

Tiswas (Tis as it is as it was)
Made from nails and known in the Black Country as a 'tiswas', this nasty weapon when thrown would always end up with a sharp spike pointing upwards. Hence, 'tis as it is as it was'. A tiswas is also a state of confusion. They were not a local invention as various forms of caltrop, as they are known, have a long history and were certainly used by the Romans. During the nailmaker's revolt of 1842 they were used to try and lame the horses of the Dragoons sent from Birmingham to disperse the protesters.

The revolt came about because of the appalling conditions suffered by poorly paid nailmakers and their families. It came to a head when the nail masters made a reduction in wages of 4s in every 20s (shillings), which amounted to a decrease of 20 per cent. Many refused to work for the lower wages, although there were those whose circumstances forced them to. On Monday 25 April 1842, thousands of nailmakers gathered from locations such as the Lye Waste, Cradley and Netherton with the intention of persuading the nail masters to pay the old wages, or force the 'knobsticks', as they were known, to

A working nailshop at the Black Country Living Museum.

Handmade nails.

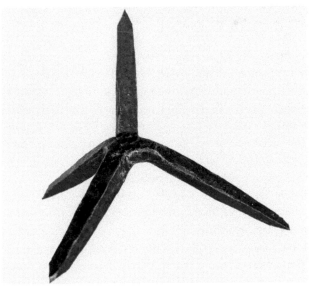

A caltrop or 'tiswas'.

cease working on the new pay rates. Having failed to achieve either, the rioters took some of the nail master's prisoner. Such was the strength of feeling among the impoverished nailmakers.

The *Times* reported that 'Mr. Nock, of Cradley Heath, Mr. Joseph Jones, of Reddall Hill, Mr. Jones, of Rowley Regis, Mr. Lewis, of Darby Hand, and other eminent ironmasters and manufacturers, were laid violent hands upon while on their own premises'. The men were frogmarched to the Dudley Arms Hotel in Dudley Market Place where a meeting took place. The nailmakers were not to know the meeting was just a ploy to buy time. Word had been sent to Birmingham and a troop of Enniskillen Dragoons had been despatched. Upon arrival, a magistrate read the Riot Act and the mounted Dragoons set about clearing the streets of rioting nailmakers. Tiswas nails were thrown to hobble the horses and force the Dragoons off their mounts but with little success. The mob was dispersed with many injuries inflicted on the nailmakers by the Dragoons charging and striking out with the flats of their swords. Despite further protests and strikes the nailmakers were ultimately defeated by the Industrial Revolution itself, and mass-produced nails made by machine.

DID YOU KNOW?
Working families would often uproot for weeks at a time in September and early October to go hop picking. Men, women and children were paid piecework rates, which by 1840 could mean 1s 6d (7.5p) a day for an experienced picker. It was sometimes known as the 'Nailmakers' Holiday' as it particularly suited the nailmakers who worked for themselves. It would be the only holiday, of sorts, that most Black Country working folk would get.

Turnpikes and Tarmac

Transporting goods in the Black Country during the Industrial Revolution generally involved paying tolls on canals and turnpike roads. Since Mary Tudor's time roads were maintained by the local parishes using unpaid 'statute labour'. Increasing traffic and poorly maintained roads led to 'Justice Trusts' from 1663 controlled by magistrates, with maintenance costs met by charging tolls. In 1707 the first Turnpike Act was passed allowing management by local trustees. By law Turnpike Trusts were non-profit making and money collected from the tolls had to be ploughed back into the roads for the payment of staff, maintenance and road improvements. Trustees benefitted from trade brought about by better roads. Turnpike Trusts boomed throughout the country with around 22,000 miles of roads controlled by nearly 1,000 trusts by 1836.

Once approval had been obtained to turnpike a road, toll houses and gates would be installed by the Turnpike Trust. The term 'turnpike' may originate from the military use of a pikestaff as a roadblock and turned to allow access. A sliding scale of charges applying to animals and drawn vehicles such as wagons and carriages would be calculated by the resident toll keeper. The right to collect tolls was also sometimes purchased from the

Woodsetton Toll House, built around 1845 for the Sedgley to Tividale Turnpike Road. (Courtesy of the Black Country Living Museum)

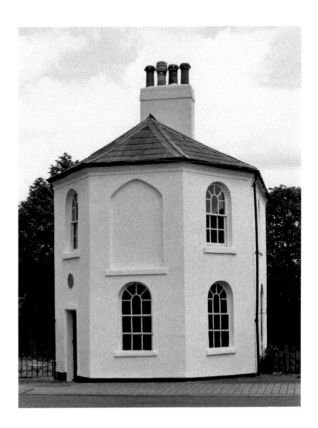

Smethwick Cross Toll House, built around 1820.

Trust at auction. The proliferation of railways from the 1840s proved to be the death knell for turnpike roads. By the 1870s, Highway Boards, followed by County Councils, took over and did away with the toll system. Removing the toll gates was a cause for jubilation. Nobody enjoyed paying tolls and of course nothing changes!

The turnpike system had stimulated improvements in road construction by the likes of Thomas Telford and John Louden McAdam. He came up with 'Macadamisation' where the road surface was cambered for drainage and made up of crushed stone laid on a bed of larger rocks. The idea of adding tar to the surface came in 1901 when Nottinghamshire County Surveyor Edgar Purnell Hooley was rambling in Derbyshire and came across a tar spillage on the road outside an ironworks. Someone had poured slag onto the spillage to cover it up and Hooley noticed what a good road surface it made. He perfected the process over 1902 and launched Tar Macadam Syndicate Ltd in 1903. Hooley was no businessman and quickly sold the company to Wolverhampton MP Sir Alfred Hickman, who was born in Tipton and owned Bilston Steel Works. In 1905 the company was relaunched as the hugely successful Tarmac.

Barrow Hill

Barrow Hill in Pensnett has an air of mystery about it with stories of buried treasure, a secret Cold War bunker and the impressive steel cross sited on top of the hill. Originally the site of an active volcano, Barrow Hill is now a nature reserve almost hidden away behind Russell's Hall Hospital. The discovery of two Bronze Age burial chambers gives the hill its name. Prior to the ravages of industry and mining Pensnett Chase was a hunting ground for the Lords of Dudley.

Stories dating back to the eighteenth century tell of buried treasure beneath Barrow Hill involving characters such as the eccentric Charles Carey, who used to dig in secret only to eventually lose his mind and his life. This was due to disturbing the bones of buried warriors according to local legend. Or Captain Belcher, who tried to supplement his wages as the local naval press gang officer with a little treasure hunting together with retired mine proprietor, William Brettle. He met his end after allegedly discovering something of value and frantically riding to William Brettle's house in Stourport, only to suddenly die of a mysterious fever upon arrival before revealing his find.

Although just stories, there is archive evidence of a John Cary (not to be confused with an earlier John Carey) who took out a ninety-nine-year lease on nearby Moushall (Mousehall) Mansion House in 1653. He had three sons and one was Charles. A Charles Cary was buried in Kingswinford churchyard in 1723. There is also evidence of a Commander Becher living at Shutt End House and, coincidentally, a Captain Beecher who was in charge of press gangs in the Stourbridge area. Little more is known of the captain, but Commander Becher was killed in a rolling mill accident at Stourton in 1783.

During the Cold War there were rumours of a secret underground radio listening station monitoring signals from the Eastern Bloc. In fact, Barrow Hill was the site of an underground ROC post. Over 1,500 of these small underground bunkers were constructed all over the country by the Royal Observer Corps. The job of the three ROC personnel would be to lock themselves safely underground in the event of a nuclear attack and report back to Group Headquarters by landline or radio. Equipment would record the

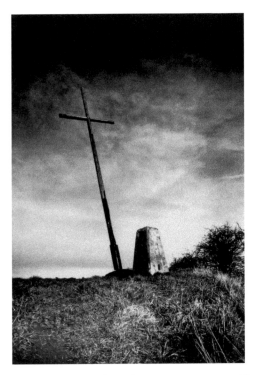 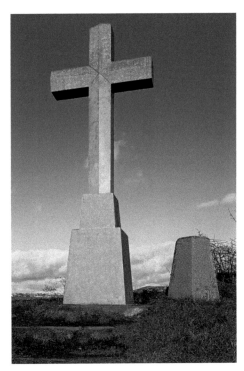

Above left: Original wooden cross on Barrow Hill. (Courtesy of Phil Cervi)

Above right: Replacement steel cross designed by Steve Field. (Courtesy of Bryan Kelsey)

position of any bomb blast, the power or yield of the detonation, and the resulting radioactive fallout. The interior was basic with a chemical toilet in the stairwell, bunk beds, desks and provisions for up to three weeks. Situated near the top of Barrow Hill, the ROC post was established in 1965 and decommissioned in 1991. Following vandalism and a fire the site was demolished. Thankfully, this largely forgotten piece of Cold War history never had to be used in earnest.

A large cross, unusually in steel, dominates the top of Barrow Hill. The history of the cross goes back to an earlier wooden one erected by nearby St Mark's Church. By the late 1990s the once emotive wooden cross had been vandalised beyond repair and Dudley Council agreed to replace it. The original design was by a famous Romanian artist, the late Constantin Popovici, who was visiting Dudley at the time. His design was for three abstract crosses in Eastern European style. This proved to be a bit too controversial and so the simple faceted steel cross was designed by borough artist Steve Field and dedicated in September 1999. The calvary of three crosses by Popovici were placed in a grove further down Barrow Hill.

2. Murder and Mystery

Gibbet Lane

The old road from Stourbridge towards Kinver has not always been called Gibbet Lane. The area used to be known as Fir Tree Hill but was changed following a notorious murder in 1812. On 18 December, gentleman farmer Benjamin Robins was returning home on foot from a successful day at Stourbridge market. He was unfortunate enough to meet up with William Howe, who had just two things on his mind: robbery and murder. Shooting Benjamin Robins in the back at close range with a pistol, Howe robbed the unfortunate man of his money, just over £20, and his silver pocket watch. Left for dead, Robins managed to stagger back home to Dunsley Hall, but died of his wound ten days later.

Such was the level of outrage in Stourbridge that two Bow Street Runners, Harry Adkins and Samuel Taunton, were employed to ensure the culprit was brought to justice. Howe was eventually apprehended in London following a thorough investigation and sent to Stafford for trial. While in Stafford Gaol Howe told another prisoner that he had pledged the pocket watch with pawnbroker Edward Power of Warwick, who later gave evidence to that effect. He also wrote a letter to his wife telling her that he had hidden one of his two pistols in a hayrick at Oldswinford. The game was up when the letter had to be read out to her. Howe should have known his wife could not read!

Howe was duly sentenced and hanged at Stafford Gaol. He had the dubious distinction of being one of the last criminals in England to be gibbeted. His body was hung in a metal cage from chains at the site of the murder as a warning to others. It seems to have had the opposite effect as the grisly sight attracted large crowds of onlookers. After hanging for eighteen months what was left of Howe mysteriously disappeared.

Dunsley Hall is now a charming country hotel and restaurant.

The eerie area around Gibbet Lane and Wood.

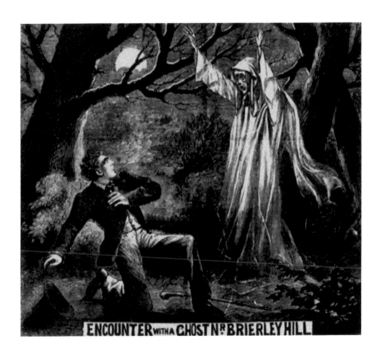

Illustrated Police News, Saturday 14 December 1872. (Courtesy of the British Library)

Since then, the ghost of William Howe is said to haunt the renamed Gibbet Lane and Gibbet Wood. In December 1872, a gentleman reported in the *Brierley Hill and Stourbridge Advertiser* that he was confronted by a terrifying figure who glided up to him and blocked his path chuckling menacingly. Lashing out with his stick, it passed right through William Howe's head and the force of the blow knocked the gentleman off his feet. He claimed to have been held down by the figure until the first rays of dawn broke whereupon 'the phantom raised both its arms, over its shadowy head, uttered once again, its mocking blood freezing chuckle, and disappeared'.

There are reports of people being followed including one from 1940 when a lady was stalked in the moonlight by a figure who made no sound and cast no shadow. He had a long neck, which she said appeared to be broken as the head was swinging from side to side. Fortunately for the lady concerned the apparition disappeared as soon as she passed the place where Howe's body had been gibbeted. To this day, dark shadowy figures have been seen and the sounds of clanking chains heard. Even in broad daylight Gibbet Lane is an eerie place to be.

DID YOU KNOW?
Walsall had the first proper police force in the Black Country established in July 1832. Prior to this it was the responsibility of parish constables and watchmen, which was an archaic and generally inadequate method of policing, particularly in industrialised areas. Walsall was also the first police force in the Black Country to employ women officers. Katherine Tearle and Miss Williams were recruited in 1918.

Hannah Johnson Cox

The Coseley Canal Tunnel takes on an eerie feeling at times and so it might. The white lady ghost who allegedly haunts here serves as a reminder of how harsh life could be for many Black Country working folk. Her apparition is said to stare silently down into the depths of the Birmingham Canal at the entrance to the tunnel. Such white lady ghost stories are fairly common but this one recalls a tragic event in 1901 which was only too real. So, who was she?

According to the 1901 census Hannah Johnson Cox was living in Hurst Hill, Coseley, with her husband Philip and four children. By all accounts Philip was a cruel man who would rather gamble than support his wife and children. When her husband deserted her, Hannah and her children were taken in by a kindly neighbour after being thrown out of their home when she could not pay the rent. Hannah was already suffering from depression after the birth of her last child and losing their home through her feckless husband's gambling was the last straw.

On the 14 June 1901, while in a deeply depressed state, she drowned her two youngest daughters in the Birmingham Canal. She tied an apron around Flora Jane, aged two, and Mary Madeline, aged just five months, and pushed them under the water near to the entrance of the Coseley Tunnel. Having done this the distraught Hannah promptly gave herself up to the local police and immediately confessed. She was later reported as saying she loved her children as she did her own life but could not bear to see them homeless. A desperate attempt was made to rescue the two little girls but, although they had already been pulled out of the water by local boatmen, it was too late. They were already dead.

The case was heard at Staffordshire Assizes by Mr Justice Bigham. Taking into account her mental state at the time and the strength of public sympathy, Hannah was found

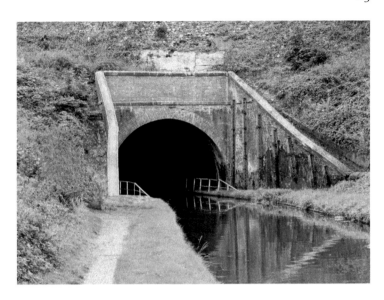

Coseley Canal Tunnel.

guilty but insane. She escaped the gallows but was ordered to be detained 'during his Majesty's pleasure' as a criminal lunatic. Philip Cox was largely blamed by local people and he evaded an angry mob outside the court by seeking refuge in the local police station. He was forced to flee for his life and sailed to New York on the *Majestic* in 1901. Once in America he married twice more despite never divorcing his first wife. Hannah was released from the asylum in 1906 and returned to Coseley to live with her brother. Hannah Johnson Cox died in 1948.

Whitechapel Murders

What are the Whitechapel Murders doing in a book on the Black Country? Well, one of the unfortunate victims was originally from this area. Catherine (Kate) Eddowes was born to a large family in Merridale Street, Wolverhampton, on 14 April 1842. Her father, George Eddowes, was a tin plate worker and it seems likely he was out of work during the prolonged strike of 1850. In any event, the census of 1851 records the family as living in Bermondsey, London, with seven of their children including ten-year-old Catherine. By 1857 both of her parents are dead, some of her siblings are in the workhouse, and Catherine returns to Wolverhampton to live with her aunt and uncle, finding employment as a scourer in the tin plate industry.

Around 1862 she takes up with Thomas Conway (also Quinn), an ex-soldier with a modest military pension, variously described as a pedlar and a hawker. Catherine has at least three children with Conway and although she describes herself as his wife, there is no evidence that they were ever married. The 1871 census places them in London at Southwark with Catherine working as a laundress. By 1881 the couple had split up and Catherine next took up with John Kelly, who did menial jobs around the markets. They too lived together as man and wife in a common lodging house at Flower and Dean Street, Southwark. A newspaper report would later describe Catherine as 'a very jolly woman, singing and jumping about'.

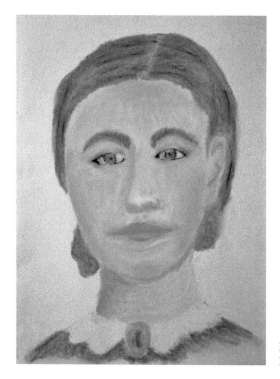

Portrait of Catherine (Kate) Eddowes by Diane Homer.

On Saturday 29 September 1888, after apparently entertaining a small crowd, a drunken Catherine is picked up from the pavement in Aldgate Street by a police officer and taken into custody to sober up. She was released from Bishopsgate Police Station at 1.00 a.m. on the Sunday morning. Instead of taking the most direct route back to the lodging house she made the fateful decision to return to Aldgate. At 1.44 a.m. PC Edward Watkins made the gruesome discovery of the murdered and mutilated body of Catherine Eddowes in Mitre Square. Aged forty-three, she was the fourth of the so-called 'canonical five' victims of a single unidentified serial killer. The last face Catherine Eddowes saw was that of Jack the Ripper.

Who Put Bella in the Wych Elm?

For over seventy years the mystery of the skeleton found in a Wych Elm has gripped the Black Country. It inspired a recent documentary, 'Who put Bella in the Wych Elm? The Untold Secrets', as well as numerous articles, books and even an opera!

At the inquest Robert Hart explained how one Sunday morning in April 1943 he and three other teenage boys were 'birds-nesting' in Himley Wood when he noticed a skull hidden in the stump of an old Wych Elm. They raked the skull out but fearful of the consequences put it back and returned home. One of the boys blurted it out to his father and a police investigation ensued. Forensic scientist Professor J. M. Webster was able to reconstruct the skeleton even though some of the bones, and one severed hand, were scattered nearby. He concluded that she was a woman of about thirty-five and 5 feet tall with crooked front teeth, who had given birth at least once. Fragments of rotting clothing had no identifying labels. He estimated the body to have been in the tree at least eighteen

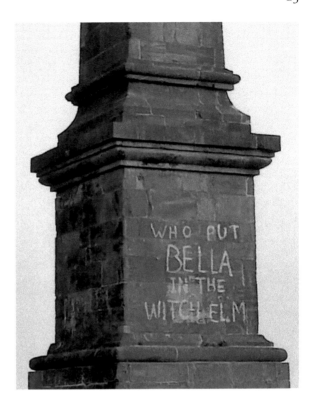

'Who put Bella in the Witch Elm' painted on the Wychbury Hill Obelisk.

The Badger's Sett.

months. A piece of clothing had been forced deep into her mouth, which may have been the cause of death. Suicide was not suspected.

There were strange aspects to the case right from the start. Nobody matching her description was reported missing and nobody came forward to claim her. In 1944 the police investigated messages chalked on walls in the market area of Birmingham and in Old Hill. 'Who put Bella down the Wych Elm Hagley Wood' was one and 'Hagley Wood Bella' another. Earlier messages had used the name Lue-Bella and Lubella. Rightly or wrongly, the murder victim was now 'Bella'.

Given the lack of evidence, speculation ran rife on how Bella ended up in the tree. Was she a German spy, a murdered prostitute or had she had been killed by travellers known to camp in the area? There was even a suggestion that she was the victim of witchcraft, which was proposed by Professor Margaret Murray of University College, London. In 1953, a woman known as 'Anna' named her as Clarabella Dronkers, who was supposedly involved with a German spy network. These remain unproven theories but with modern forensics the mystery could probably be solved. That is if Bella's skeleton had not inexplicably disappeared from Birmingham Medical School along with other valuable evidence over the years.

Hagley Wood, the nearby A456 Hagley Road and the Gypsy's Tent public house (now the Badger's Sett), has long been subject to reports of paranormal activity. In the pub lights get turned on and off after hours, doors open and close, things get moved around, cold draughts are felt, and a shadowy figure assumed to be Bella has been seen. Mysterious figures have also been seen outside on the main road. Jayne Harris's documentary records an interview with an eyewitness to a lady in unusual 1940s-style dress who simply vanished behind a tree in Hagley Wood.

The *Birmingham Daily Gazette* for 28 November 1953 carried a story that the original message writer in Birmingham and Old Hill had been traced by the police. Apparently, he was not connected with the murder and Superintendent Williams was reported as saying, 'it seems that 'Bella' was not even Bella after all'.

DID YOU KNOW?
The well-known Hagley Monument or Obelisk on Wychbury Hill was just one of a number of follies created by the Lyttleton family of Hagley Hall in the eighteenth century. One of these is the Grade II listed 'mock' ruined castle designed by architect Sanderson Miller and reputed to be the first of its type in England. Another first is the Grade I listed Temple of Theseus by James 'Athenian' Stuart, which was the first authentic English copy of a Greek Doric temple.

Kidnapped!

A rumour was circulating in 1906 that six chainmakers had been kidnapped by the Germans and were being forced to teach them the English methods of making cable

chain for ship's anchors. There was at least some truth to this, and it was a cause of great concern given that a naval arms race was taking place with Germany at the time.

A company from Duisberg had legitimately placed an advert in the *Newcastle Chronicle* for 'Chainsmiths' to work at a factory situated on the Rhine. This advert had come to the attention of two chainmakers who responded for further details not thinking any more would come of it. In fact, a representative from the company came to the Black Country to interview the men accompanied by an interpreter from Leeds. The Germans were keen not just to secure the services of the two chainmakers but also their strikers, realising the importance of the teamwork involved in producing cable chain. In the event six men, two chainsmiths and their strikers succumbed to the very generous terms offered and agreed to go to Germany to teach English methods of making cable chain. Thomas Sitch, Secretary of the Chainmakers and Strikers Association, was in no doubt that the men had been lured to Germany by all sorts of grand promises.

The men were initially treated very well by the Germans, who were amazed at the strength of the cable chain they were able to produce. So much so that on one occasion the men were invited to a garden party and sumptuous meal hosted by the Managing Director on the lawn of his own house. It was a different story back home. Everyone, apart from the men themselves, could see the seriousness of what the Germans could learn from them. The consensus was that they must be 'rescued'. Thomas Sitch and a representative from their former company were despatched to Germany to bring them back. The pair managed to track the men down to Duisberg where they were staying. No amount of persuasion could convince the men to return to England. From their point of view, they had good, well paid jobs and were being well looked after by their new employer. Their mission a failure, Thomas and his companion returned home.

Sometime later a communication arrived from the men saying they were now fed up of working for the Germans and that they were willing to come home. Thomas Sitch resolved to return to Germany and fetch them back. This time he was accompanied by

Ship's cable chain with a centre stud link to prevent tangling. (Copyright Dave Marsh)

Thomas Sitch.

Sydney Fellows. Fellows Brothers Limited was a well-known name in chain making and Sydney would have been able to assure the men of employment on their return. Back in Duisberg they found a very different situation. The reason the men had not returned of their own volition quickly became obvious. They were being closely watched by men described as 'interpreters'. Getting the men safely out of Germany whilst avoiding an international incident was not going to be easy. Thomas and Sydney had to come up with a rescue plan. The idea they came up with was to buy train tickets for them all and secretly let the men know when to meet them. It was Sydney who managed to pass a note discreetly to one of the men. The plan worked. The men managed to escape unseen and by the time anyone realised what had happened they were all making their way safely back to England.

Thomas Sitch himself wrote this up on the eve of the First World War in a souvenir booklet celebrating twenty-five years of the Chainmakers and Strikers Association. He was careful to conceal the identities of the men involved for fear of repercussions on them or their families. They had, after all, gone to Germany willingly. After over a century the mystery of who these men were can finally be resolved thanks to the *Birmingham Daily Gazette* of 18 June 1906. The chainmakers were Tom Ellis and Titus 'Tite' Nock together with their strikers Jock Nock, G. Kendall, Jack Harris and S. Newton. In the words of Thomas Sitch, it was a 'stirring episode' and 'a plot that failed'.

The Grey Lady of Dudley Castle

One of the best-known hauntings in the Black Country is that of the Grey Lady of Dudley Castle. She allegedly haunts the area around the base of Dudley Castle Keep forlornly searching for her husband and child. Grey lady apparitions are not uncommon, but this particular lady has both a name and a documented history dating back to the English Civil War. So, who exactly was she?

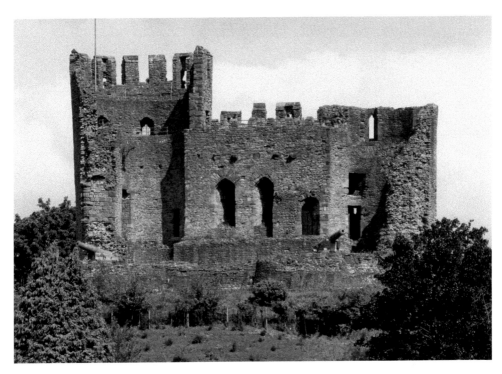

Dudley Castle keep.

Dorothy Beaumont was the wife of Lieutenant Colonel John Beaumont, Deputy Commander of the Royalist forces at the castle during the siege by Parliamentarian forces in 1646. Dorothy had given birth to a daughter, Frances, in 1645 but the child only survived a few months. Her body was buried at St Edmund's Church, Dudley, known locally as 'bottom church'.

Dorothy never recovered from this loss and passed away herself during the siege. Her body, though, could not be buried with that of her daughter as Colonel Leveson, commander of the Royalist forces, had St Edmund's Church demolished, along with other buildings in Castle Street, prior to the siege of 1646. His intention was to deny the Parliamentarians as much cover as possible. A new St Edmund's Church was built around 1724.

In letters to and from Colonel Leveson and the Parliamentarian commander Sir William Brereton, the latter gave permission for Dorothy Beaumont to be buried in the Church of St Thomas, known locally as 'top church'. In reply to Leveson Brereton writes, 'Upon my entrance into this town [Dudley] I found your drum with a letter desiring to bury Lt-Col. Beaumont's wife in the upper church, which is such a civility as I will not deny'. He also permitted the body to be accompanied by twelve named mourners. A notable exclusion from this list being Colonel Beaumont, Dorothy's husband.

Dudley Zoo and Castle used to host regular ghost walks here using actors and actresses to play the ghosts. More than once visitors have asked why there was a second 'Grey Lady' on the castle keep in addition to the actress playing her. It seems Dorothy Beaumont herself would sometimes put in a spectral appearance during these evening ghost walks.

Who Lies Beneath?

Heavyweight champion boxer William Perry, nicknamed the Tipton Slasher, is well known in the Black Country but there is something of a mystery surrounding where his remains are finally at rest. He was buried at St John's Church in Kates Hill, Dudley, after dying of alcoholism and pulmonary congestion at home in Bilston on Christmas Eve 1880. It is also claimed that the Slasher's remains were removed from St John's churchyard and reinterred beneath his statue in Coronation Gardens, Tipton.

Although known throughout his bare-knuckle boxing career as the Tipton Slasher due to his signature slashing blow, his first nickname was 'Capital K Legs'. This was due to his unusual stance after contracting rickets as a child. Throughout his long boxing

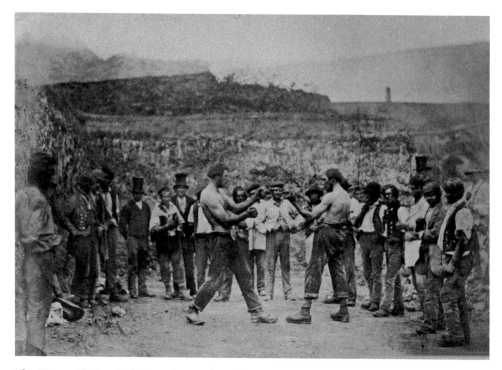

The Tipton Slasher in 'A Set-to', 1855. (Royal Collection Trust/Copyright Her Majesty Queen Elizabeth II 2020)

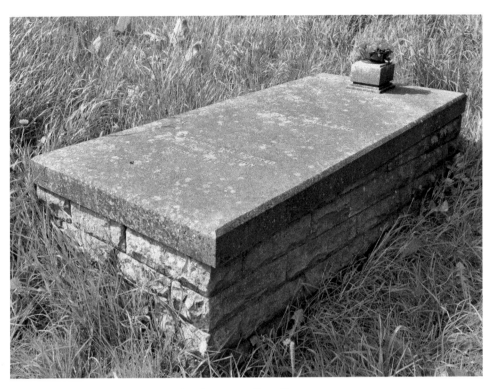

William Perry's grave in St John's Church, Kates Hill, Dudley.

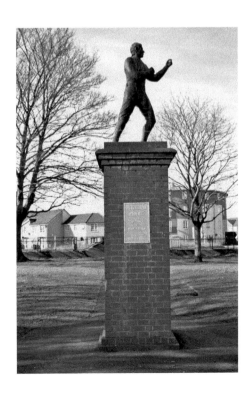

Statue of the 'Tipton Slasher' in Coronation
Gardens, Tipton.

career, William Perry was a formidable opponent, winning the English Heavyweight Championship against Tom Paddock in 1850. After a controversial fight against Harry Broome in 1851 the Slasher lost his title after the referee declared a foul against him. Harry Broome probably wisely forfeited the rematch against the furious Slasher who held his title until 1857 when he lost against Tom Sayers. By now overweight and relatively unfit, William Perry risked everything he had on the fight including his pub. The younger, fitter Tom Sayers forced the Slasher to concede defeat in just ten rounds. The Tipton Slasher's boxing career was over, apart from the occasional exhibition match.

The sculpture which has given rise to speculation on the Slasher's final resting place was unveiled in 1993. Commissioned by the Tipton Slasher Association, the appeal to raise the £25,000 was launched by Martin Collinson and Jim Holland. Support came from the general public, local businesses, and community organisations all keen to see a suitable memorial erected. The life-size statue was designed by sculptor Bill Haynes in bronze and stands on a 10-foot brick plinth.

It was the 2011 book *The Story Behind the Statue* by Perry Beauchamp that first proposed the idea that the Tipton Slasher's remains had been moved to beneath the statue. The memorial in St John's churchyard was paid for by public subscription in 1925 after the original had fallen into disrepair. By the early 1990s the grave was once again neglected, and the story goes that a small group of Tipton men decided to bring the Slasher home and bury his remains under where the new statue was to be erected. Apparently, they managed to retrieve the bones under cover of darkness and without being seen. As the Slasher's grave is immediately behind the church this clandestine operation, if it can be believed, is unlikely to have been seen by passers-by on St John's Road. As far as St John's Church is concerned, he is still there.

The truth might never be revealed without digging beneath the statue. This might happen one day as the base hides a time capsule containing details of William Perry's career and the efforts to preserve his memory. If this is ever recovered the mystery of the Tipton Slasher's final resting place might finally be solved.

3. Penny Black and Red Emma

Penny Black

Postal reformer Rowland Hill was born in Kidderminster but spent the early part of his life living near Wolverhampton. His father, Thomas Wright Hill, had been apprenticed to his uncle, a brass founder in Birmingham. Here, he became acquainted with the ideas of scientist, philosopher and Lunar Society member Joseph Priestley, and would later teach in his Unitarian Sunday School. After marrying and moving to Kidderminster, Thomas lost the Hill family home when his textile business failed. A move to Wolverhampton followed to obtain work but this left the family in impoverished circumstances.

They rented Horsehills Farm at a suspiciously low rent. Thomas discovered later that the rent was low because the old property was supposedly haunted. Rowland would later write that his father 'cared much about a low rent and nothing about ghosts'. During their time at Horsehills, the family got to know local manufacturer and Liberal Party leader Joseph Pearson. Joseph's daughter Caroline was of a similar age to the six-year-old Rowland, and they became close friends. A blue plaque on the front of the old Wolverhampton Post Office in Lichfield Street commemorates their marriage at St Peter's Church in 1827.

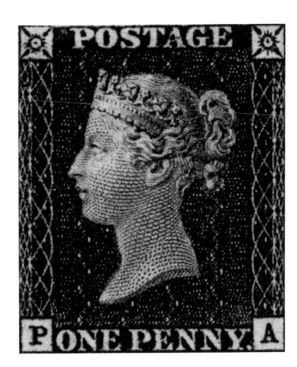

The world's first postage stamp.
(Copyright British Library Board)

Penfold pillar box made by Cochrane, Grove & Co. of Dudley. (Courtesy of the Black Country Living Museum)

The old Wolverhampton Post Office in Lichfield Street.

In 1802, an opportunity arose which Rowland's mother, Sarah, was quick to recognise. One of their friends Thomas Clarke, who had also been a member of Joseph Priestley's congregation, wanted to sell his school in Birmingham. Favourable instalment terms were agreed, and Thomas became headmaster of what would become Hill Top School in Gough Street. By the age of twelve Rowland was teaching at the school and at seventeen also taught navigation one day a week to a young midshipman at a friend's school in Stourbridge, involving a 12-mile walk in all weathers. Rowland Hill would go on to design Hazelwood School in Edgbaston, which became a model for the education of middle-class boys.

It is reform of the postal system that Rowland Hill is best known for with his introduction of the Penny Post in 1840. Prior to this, the recipient of a letter would pay the postage. It was an inherently unfair system whereby poorer people often could not afford to receive mail while Members of Parliament frequently abused the 'franking privilege', which gave them free mail. His great innovation was prepaid post with an affixed stamp, originally the Penny Black, making the cost the same for both rich and poor. Rowland Hill had known what it was to be poor and in later life wrote that his mother once said she was 'afraid lest the postman might bring a letter while she had no money to pay the postage'.

DID YOU KNOW?
The standard colour for post boxes up until 1874 was green rather than the familiar 'pillar box' red. From 1866 to 1879 hexagonal Penfold pillar boxes, made by Cochrane, Grove & Co. of Dudley, had become the standard design. Between 1874 and 1884 post boxes, including Penfolds, were repainted red simply to make them more visible.

Red Emma

A blue plaque outside the former Wolverhampton council offices commemorates Emma Sproson, but who was she and why was she nicknamed Red Emma? Born Emma Lloyd in 1867 to an impoverished West Bromwich family, her mother struggled to bring up seven children while her father drank heavily. Aged nine, Emma went into service and at thirteen had secured work in a shop. She was dismissed after complaining of sexual harassment by the proprietor's brother. Emma moved to Lancashire for work, also becoming a Sunday school teacher and joining the church debating society. The turning point came when she asked a question of Lord Curzon at a political meeting. As a woman he deemed her unworthy of a reply because she 'did not have the vote'. Emma returned to Wolverhampton in 1895 and set up a small shop with her mother. Now interested in politics and women's rights, she joined the local Independent Labour Party. Here she met and married the local secretary, Frank Sproson, a postman.

Emma supported the peaceable women's suffrage movement, but this changed in 1906 when her husband invited Emmeline Pankhurst of the militant Women's Social and

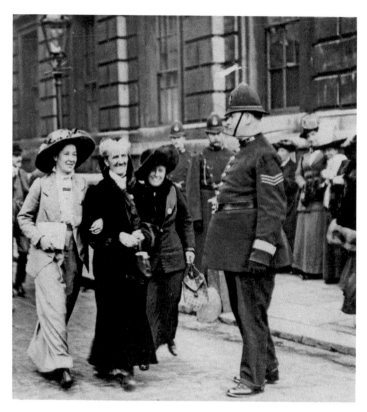

Women's Freedom League. From left to right: Edith How-Martyn, Charlotte Despard, and Emma Sproson. (Courtesy of LSE Library)

The former Wolverhampton council offices.

Political Union (WSPU) to speak in Wolverhampton. As a result, Emma turned from peaceful suffragist to militant suffragette. On 13 February 1907 Emma attended the first of a series of 'Women's Parliament' meetings at Caxton Hall in London, organised by the WSPU. Following the meeting, some 400 women marched on Parliament and over fifty arrests were made by the police including Emma. She refused to pay the court fine and spent two weeks in prison. The following month she took part in a deputation to the House of Commons, which also resulted in imprisonment, this time for a month. After being released, Emma continued to campaign around the Black Country on behalf of the WSPU.

By the end of 1907 dissatisfaction with the Pankhurst's undemocratic leadership led to the formation of the Women's Freedom League (WFL) by leading WSPU members including Charlotte Despard, Edith How-Martyn and others. Emma also joined the WFL, which supported non-violent protest. She undertook countrywide speaking engagements, as well as chairing the Wolverhampton branch of the WFL. Joining the Women's Tax Resistance League in 1911 led to another prison sentence on the basis of 'No vote, No tax'. This time she was imprisoned for a week after refusing to buy a dog licence. By 1912 Emma became disillusioned with the WFL and turned to local politics.

In 1919 and 1920 Emma fought unsuccessful local elections for the Labour Party. Standing again in 1921 she was elected councillor for the Wolverhampton Dunstall ward. She was Wolverhampton's first female councillor. In 1922 she sparked controversy by exposing financial irregularities in a local fever hospital. She won a by-election in 1924 but enraged Labour colleagues by criticising them over expenses claims! Disillusioned again, Emma left the Labour Party to stand as an independent candidate in 1927, only to finally lose her Wolverhampton seat.

As to the nickname, Emma was so exuberant following her victory in 1921 that she ran up the steps of Wolverhampton Council building and waved a red flag from one of the windows. From then on, she was known as 'Red Emma'.

DID YOU KNOW?
In 1919 Nancy Astor was the first woman to take her seat in the House of Commons but she was very nearly beaten by Mary Macarthur. Mary was famous locally for having led the chain making women of Cradley Heath in the successful strike of 1910. In 1918, the first year that women were allowed to stand for Parliament, Mary Macarthur stood for Labour in Stourbridge. Unfortunately, the returning officer insisted that her married name of Anderson should appear on the ballot paper and she lost by just 1,333 votes to the Liberal candidate.

4. Science and Industry

Local 'Lunartick'

Although born in Scotland, eminent chemist and industrialist James Keir lived much of his life in Hilltop, West Bromwich. The Black Country, unlike Birmingham, is not immediately associated with the Lunar Society and the Midlands Enlightenment, yet James Keir was one of its principal members. The society met on the nearest Monday to the full moon and members were nicknamed 'Lunarticks'.

Often overlooked, Keir was in the company of fellow members such as Matthew Boulton, James Watt, and his friend from university days, Erasmus Darwin. Keir left university to join the army but resigned his commission in 1768 to pursue his interests in chemistry and geology. A move to the Black Country provided the perfect environment to pursue his interests alongside like-minded members of the Lunar Society. By 1771 he had married novelist Susanna Harvey and their only surviving child, Amelia, would later write a 'sketch' of her father's life. In 1772, Keir was leasing a glass house in Amblecote and running it with two partners. One of his foremost customers was Matthew Boulton and from 1778 Keir managed the Soho Manufactory on behalf of Boulton and Watt. While at Soho, Keir patented a lightweight but strong alloy of copper, zinc, and iron that could be hot or cold forged and was much favoured over wood for decorative sash windows in many a fine house.

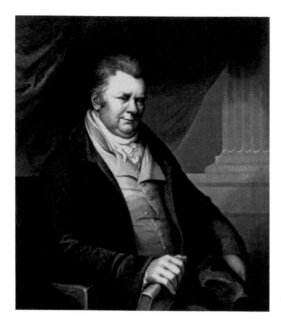

James Keir. (Contributor: Alamy Stock Photos)

Matthew Boulton's Soho House in Handsworth where the Lunar Society met.

James Keir's Moonstone. One of the nine carved memorials to members of the Lunar Society in Queslett, Great Barr.

In 1780 Keir left the Soho Manufactory to establish his own chemical works at Bloomfield Tipton together with an old army friend, Alexander Blair. James Keir & Co. manufactured alkali and lead compounds for the glass industry. By 1794 they also had a coal mine in Tividale, which enabled Keir to pursue another of his many passions, mineralogy, resulting in a paper that was published in Stebbing Shaw's *History and Antiquities of Staffordshire* (1798–1801). The alkali they were producing was ideal for one particular product, and that was soap. At the end of the nineteenth century Merseyside had Port Sunlight, famous for Sunlight Soap, but in the eighteenth century the Black Country had Tipton. The Soap Works, as it would become known, covered some 20 acres and was second only in size to the Soho Manufactory. All that remains now is Factory Road, which was once named Soap Factory Road.

One of the reasons James Keir is not better known is that many of his papers were lost in two fires, one in 1807 at his home in Hilltop and another in 1845 at his daughter's home, Abberley Hall. He died aged eighty-four in 1820 and was buried at All Saints Church, West Bromwich, although there is no headstone to be found. In common with Richard III, it is thought he is buried somewhere beneath the present-day car park.

Banishing the Blue Death

As the Black Death ravaged the area in medieval times, the nineteenth century saw the horror of the Blue Death. This was Asiatic cholera, nicknamed the Blue Death because the bodies would often be tinged with blue. Causing severe diarrhea and dehydration, cholera often resulted in a rapid and unpleasant death. This disease devastated the Black Country with places such as Bilston and Tipton being particularly badly hit. In 1832 Bilston suffered 742 deaths followed by Tipton with 404 deaths. A further major outbreak in 1849 saw over 700 victims in Bilston alone.

The overriding theory as to how diseases such as cholera were transmitted was miasma, which wrongly put the blame on the filth and foul air found in poorer, overcrowded areas. This led to improvement schemes in sanitation and clean water supplies. A case of doing the right thing for the wrong reasons. It was not until 1854 that Dr John Snow tracked a cholera outbreak in London's Soho to a standpipe and confirmed his then controversial theory that the disease was actually spread through water contaminated by untreated sewage. Dr William Norris of Stourbridge had also concluded that cholera was transmitted through liquids but his report to the General Board of Health is now largely forgotten.

Formed in 1834, the Dudley Waterworks Company was an improvement scheme that supplied water to Dudley and Bilston. A reservoir at Parkes Hall in Woodsetton was dug and water pumped to Shavers End, near Dudley. Inadequate coverage, intermittent supply and high cost meant that many families were still forced to rely on unclean industrial and canal water. In December 1852 John McClean, Consultant Engineer to Dudley Waterworks and lease holder of the South Staffordshire Railway Company, formed the South Staffordshire Water Company with five other railway board members. The 1853 prospectus stated that, 'This Company has been formed for the purposes of affording an abundant supply of pure water to the inhabitants of the city of Lichfield and the important towns of Walsall, Bilston, West Bromwich, Wednesbury, Darlaston, Great Bridge, Dudley, Willenhall, Oldbury, Tipton and Wolverhampton'.

Former Dudley Waterworks Company Parks Hall Reservoir in Woodsetton.

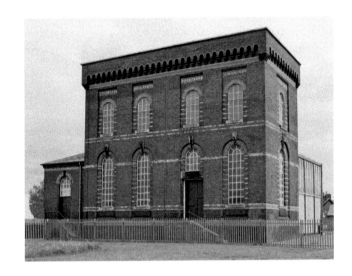

Grade II* listed Sandfields Pumping Station in Lichfield.

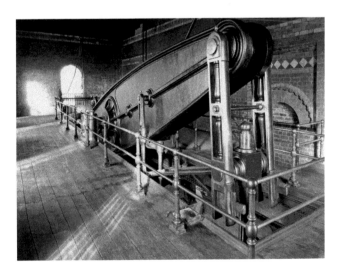

The preserved 'Cornish Style' beam engine built by Jonah and George Davies of Tipton. (Courtesy of Lichfield Waterworks Trust)

An 1853 Act of Parliament paved the way for clean water to be pumped the 11 miles from Lichfield to Walsall requiring new reservoirs at each end, and in February 1856 Lord Ward of Dudley turned the first sod at Lichfield. In October 1858 Lord Ward again officially turned on the water supply from the newly built Sandfields Pumping Station. Over the next few years clean water was piped around the Black Country and in 1862 took over the supply from the Dudley Waterworks Company. The original 1858 engine house is sadly demolished but what remains is the magnificent 1873 blue brick housing for the fourth steam pumping engine to be installed. The building still contains the 190 horsepower Cornish beam pumping engine supplied by Jonah and George Davies of the Albion Foundry, Tipton. The Lichfield Waterworks Trust is a voluntary group working hard to preserve this historic site. Sandfields Pumping Station helped save the Black Country from cholera and banish the scourge of the Blue Death.

Earthquake Man

Had the great Himley earthquake of 2002 happened in 1908 one man in West Bromwich would certainly have known about it. That man was John Johnson Shaw. Born in 1873 at Lower Gornal into a pawnbroking family, he showed a natural aptitude for science and completed his early education at King Edward VI Five Ways School in Birmingham. At age sixteen he left school to begin a successful engineering apprenticeship, which was to hold in him good stead for the future.

A holiday on the Isle of Wight in 1896 would change the course of Shaw's life when he paid a surprise visit to the recently retired Professor John Milne, who was living at Shide Hill House, near Newport. Milne had been the first Professor of Mining and Geology at the Imperial College of Engineering in Tokyo and is widely regarded as the 'father of modern seismology'. That visit sparked a friendship that would last until Milne died in 1913. The young Shaw was fascinated by Milne's seismology 'observatory' at his home

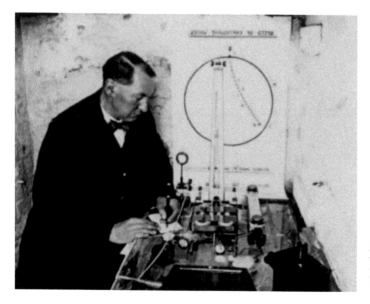

John Johnson Shaw working in his laboratory. (Courtesy of Sedgleymanor.com)

West Bromwich Central Library commemorative plaque. (Courtesy Sedgley Local History Society)

and learnt enough on that first visit to build his own makeshift device and create an observatory in his own cellar. Shaw's first seismograph was constructed from bits and pieces around his home including an old bicycle frame, a cheap German clock for the timing mechanism, a Tate and Lyle tin for the recording drum, and a Hudson's Soap box for the housing. It worked, and from then on Shaw was hooked.

After marrying Maud Cater in 1900, and having a son Harold in 1903, the family were settled and doing quite well in West Bromwich, even employing a domestic servant or 'maid of all work'. Shaw had returned to the family business as a pawnbroker while pursuing his interest in seismology and making a name for himself as an amateur scientist. He came to the attention of the press in 1908 by being the first in Britain to announce the 13th October Mexican earthquake. Later in 1908 he detected the terrible earthquake that killed around 80,000 people in Messina, Italy. As far as the press was concerned, he was now the 'earthquake man'.

By 1913 Shaw had made a tremendous improvement to John Milne's original design. The Milne-Shaw Seismograph, as it was known, improved the magnification by up to 500 times by combining optical and photographic recording. Unfortunately, Milne did not live to see what a great step forward this was. Milne-Shaw Seismographs would become standard equipment for measuring earthquakes all around the world with some still in use up to the 1960s. Amazingly, Shaw and an assistant called Spencer would build them in his greenhouse from components supplied mainly by Black Country companies.

Among the many accolades during his lifetime John Johnson Shaw was awarded a CBE in 1931. He died in 1948 but is now largely forgotten in the Black Country. He only seems to be commemorated in West Bromwich with a plaque in the library and the naming of Shaw Street.

The Father of Modern Computing

Famous names in the history of computing include the likes of Charles Babbage, Alan Turing and John Von Neumann. One name less likely to spring to mind is that of Maurice Wilkes. Born on the 26 June 1913 in Dudley, his father worked in accounts on the Earl of Dudley's estate. Wilkes attended King Edward VI Grammar School in Stourbridge where it was clear he excelled at maths and was keenly interested in engineering and radio. A contemporary of his at the Grammar School, Winston Homer, recalled Wilkes as being 'more of a scholar than a sportsman'. Scholar he certainly was, as after leaving school he studied mathematical physics at Cambridge and later joined the Cavendish Laboratory to research radio wave propagation.

During the Second World War Wilkes was involved in important work on radar and was later posted to the Telecommunications Research Establishment (TRE) at Malvern to work on the top-secret OBOE radio navigation blind bombing aid. His extensive knowledge of valve technology and mercury delay lines (used as memory storage for radar screens) would stand him in good stead when after the war he came to build the world's first practical software programmable computer at Cambridge University.

Prior to the EDSAC (Electronic Delay Storage Automatic Calculator) in 1949, earlier computers were either dedicated to a single task such as Colossus, designed to break the German Enigma code, or just experimental such as Manchester University's small scale 'Baby' machine. Maurice Wilkes had succeeded in building the world's first practical multipurpose computer using stored programs. 6 May 1949 when EDSAC ran its first simple program was the day modern computing was born.

The former King Edward VI Grammar School in Stourbridge which is now a sixth-form college.

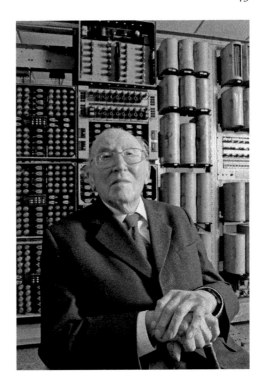

Sir Maurice Wilkes at The National Museum of Computing, Bletchley Park. (Contributor: Alamy Stock Photos)

In 1951, together with two colleagues, Wilkes published *The Preparation of Programs for an Electronic Digital Computer*, which was the first book dedicated to computer programming. The term 'software' would not be coined until some years later. By the time Professor Maurice Wilkes was knighted for his many important contributions to computing in the year 2000, his ideas had developed from a specialist tool for academics to home computers and a widespread concern about the millennium bug!

Maurice Wilkes was also an expert on the history of computing and especially the life and work of Charles Babbage and his ideas for mechanical computing engines in the nineteenth century. If Charles Babbage is the father of computing and Alan Turing the father of computer science, then Maurice Wilkes surely deserves his place in history as the father of modern computing.

Thomas Sheldon and Joseph Gillott

Birmingham was synonymous with the manufacture of pen nibs and pens. It was Joseph Gillott who perfected the mass production of pen nibs, but he was not the only one. In fact, Birmingham accounted for up to 75 per cent of the world's pens at the height of the nineteenth-century trade. Major players who industrialised pen nib production also included John and William Mitchell, James Perry and Josiah Mason. While they certainly created the industry in Birmingham none of them can lay claim to having invented the steel pen nib.

It is not possible to say with any degree of certainty who first invented the steel pen nib but a clue to very early manufacture is given on the official civic badge of the former

Box of Josiah Mason's Perry steel pen nibs. (Photo by Birmingham Museums Trust, licensed under CC0)

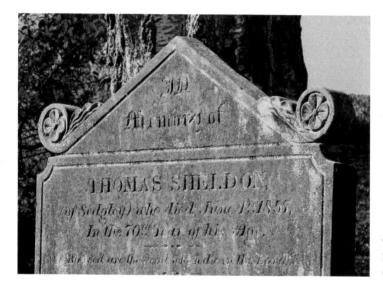

Thomas Sheldon is buried at All Saints Church, Sedgley.

Sedgley Urban District Council. Two pen nibs appear on either side of the Stafford Knot, often wrongly referred to as the Staffordshire Knot, which it is not! It is a reference to Sedgley blacksmith Daniel Fellows and his apprentice Thomas Sheldon. According to local history, Daniel Fellows claims to have invented the steel pen nib around 1800 and set Thomas Sheldon, his apprentice, to work making them.

In 1869 the *Birmingham Daily Post and Journal* began publishing a series of letters in its 'Local notes and queries' section. This was in response to a reader querying the history of steel pen nibs, 'while the facts are fresh and many persons still living would give evidence'. A number of published replies to this query mention Fellows and Sheldon of Sedgley. One correspondent refers to Daniel Fellows making 'steel pens' in 1800 while another with the pen name Sait claimed that Fellows had been making pens as early as

1793 and that he had seen Sheldon making pen nibs in 1806. He also pointed out that the trade later declined due to the mass-produced pens of manufacturers such as Joseph Gillott in Birmingham. Another writer with the initials T. S. recalled his uncle buying barrel-shaped pen nibs from Sheldon in 1815.

An intriguing connection between Thomas Sheldon and Joseph Gillott is mentioned in a letter from J. Sargent of Tettenhall published on 28 June 1869. Sargent not only confirms that Daniel Fellows was the first to make 'steel pens' but also reported that, 'Sheldon himself told me that Mr. Gillott commenced making the pen from seeing some of his (Sheldon's) make'. If Sargent was correct, Birmingham's extensive pen trade may have developed from a meeting between Thomas Sheldon and Joseph Gillott right here in the Black Country.

DID YOU KNOW?
One of the men credited with making the world's first commercial steel pen nibs switched from pens to pints when Thomas Sheldon took over the original Seven Stars public house in Gospel End Street, Sedgley.

King of the Ironmasters

What do you do if there are not enough coins in circulation to pay your workers? The answer for John 'Iron Mad' Wilkinson in the eighteenth century was to mint his own. A larger-than-life character, Wilkinson had ironworks in Wales and Shropshire together with his most successful enterprise at Bradley in the Black Country. He is well known for developing the boring bar for military cannon, but he also provided the highly accurate cylinders and other precision parts for the steam engines of Matthew Boulton and James Watt. Less well known is that it was mainly Wilkinson's drive and promotion of cast iron that brought Shropshire's famous 'Iron Bridge' into being. Construction started in 1777, but by then he had sold his shares to Abraham Darby III, who actually built the bridge, which officially opened in 1781. As well as iron, Wilkinson had serious interests in copper together with Thomas Williams, the 'Copper King', and Matthew Boulton. He was well placed to issue his own copper tokens in lieu of coinage from the Royal Mint.

From 1770, the government of George III managed to satisfy demand for copper coins, particularly halfpennies. By 1775 though the Royal Mint's supply of lower value coins had ceased, eventually leading to a shortage. In order to pay his workforce, Wilkinson set about literally making money. From 1787 to the end of the eighteenth century Wilkinson had his own copper tokens minted firstly at the Parys Mint of Thomas Wilkins on Anglesey, but then mainly by Matthew Boulton at his steam driven Soho Mint. Wilkinson's halfpenny tokens were of good quality and proved popular. At first, their value could be redeemed at Willey, Snedshill, Bersham and Bradley as stamped around the edges. Later they would also be redeemable in Anglesey, Liverpool and London.

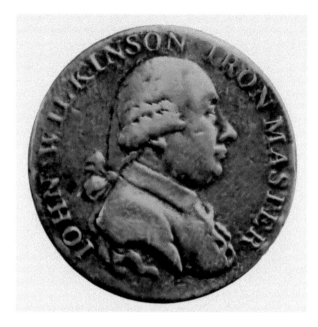

Copper token with the obverse bearing the head of John Wilkinson. (Courtesy of Chris Turton)

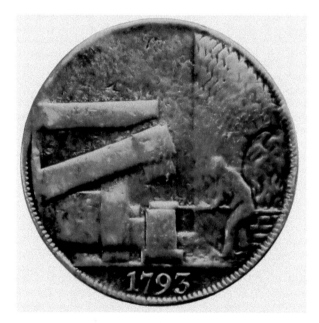

Reverse of the token featuring a forge. (Courtesy of Chris Turton)

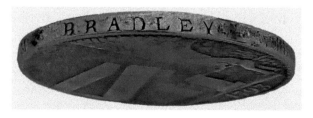

Redeemable at Willey, Snedshill, Bersham and Bradley as stamped on the edge of the token. (Courtesy of Chris Turton)

The reverse of his tokens carried industrial designs while it was the preserve of royalty to have their heads stamped on the obverse. Wilkinson chose to have his own head on the halfpenny tokens, which were in effect private coins. After all, according to Thomas Telford, he was 'King of the Ironmasters'. Stamping his face on his own money did not go without satirical comment. The last line of an 'Epigram' penned in the *London Magazine* of 1787 reads:

> So, thus, in him 'twas very proper,
> To stamp his brazen face on Copper.

DID YOU KNOW?
John (Iron Mad) Wilkinson was an early pioneer of iron boat hulls replacing wood. Following experiments at Bradley, the 'Trial' was launched in 1787 on the River Severn in Shropshire, but this was an unpowered river barge. The very first iron steam ship to go to sea was the Aaron Manby. This was fabricated in Tipton at the Horseley Iron Works and went to sea in 1822.

Iron Mistress

The Trade Chat column of *The Ironmonger* journal in December 1938 suggested that Black Country 'Iron Mistress' Eliza Tinsley was largely a legendary figure whose very existence was 'wrapped in mystery'. Major Harry Green of Eliza Tinsley & Co. was more than happy to put the record straight.

Working women had a hard life in the Black Country. Nail making, chain making, and many other industries employed thousands of women and girls. It might be assumed that running a business, especially in the iron trade, was exclusively a male preserve in the nineteenth century, but this was not always the case. A married woman could end up taking over the family business following the death of her husband. This was to be the experience of Eliza Tinsley, except that she took a relatively small nail making business and turned it into an international success story.

Eliza Butler was born in 1813. Her father was Benjamin Butler, a file maker who later kept the Fleece Inn (later Golden Fleece) in Wolverhampton. The Butlers were a well-established Willenhall family and Eliza likely benefited from an education along with her three surviving brothers. In 1839, she married Thomas Tinsley at All Saints Church in Sedgley. Thomas and his father were successful in the nail trade and Theophilus Tinsley was also the licensee of The Leopard public house. Theophilus bought land near his Sedgley pub called Quarry Piece for the couple to build a substantial home. Eliza would call this The Limes, a reference to earlier lime workings on the site. By May 1851 when they moved in, she had five surviving children but just a month later in June lost her husband to a sudden illness. Theophilus had already died in 1849 and everything now suddenly changed for Eliza Tinsley.

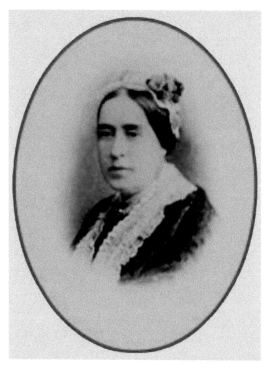

Eliza Tinsley. (Courtesy of Eliza Tinsley Limited)

The Limes. Former Victorian home of Eliza Tinsley.

Within a short space of time Eliza was running the family nail business. She became known as 'The Widow' and built up a reputation for treating her workers fairly. Many worked from home on piecework rates, only being paid for what they made, which was open to blatant exploitation especially in the nail and chain trades. Eliza rapidly enlarged the family nail business to encompass a much wider range of iron goods including chain. By 1871 she was employing around 4,000 workers. Eliza was by now running efficient and well-managed factories such as those situated at Great Bridge and Cradley Heath. She also expanded her business interests overseas in places as far away as Melbourne, Australia. Elisa Tinsley died of a heart attack at The Limes in 1882. She would be remembered both as a businesswoman and unstinting supporter of various charitable causes.

One of the partners who took over the successful company was G. Harry Green, who had worked for Eliza as a sales representative. The long association with the Green family continues to this day. To commemorate a business trip to Aberdeen by Eliza Tinsley and 'Old Harry Green', as he became known, a poem was penned in 1865. The last verse serves as a fitting epitaph:

> Your Mistress' confidence you have,
> And also her esteem,
> Your Customers respect you much,
> To cheat would never dream.

World's Fastest Slug

In the 1920s the name Sunbeam dominated world land speed records. Registered in 1888 by John Marston, Sunbeam developed from making bicycles to the manufacture of motorcycles and cars. In 1905 the Sunbeam Motorcar Co. Ltd was formed, and in 1906 production commenced at the purpose-built Moorfield Works in Villiers Street, Blakenhall. The appointment of Frenchman Louis Coatalen as Chief Engineer saw a move into motor racing to stimulate sales before and after the First World War. Almost inevitably the quest for speed led to record breaking attempts, including the prestigious world land speed record.

Early success came in 1922 when racing driver Kenelm Lee Guinness, a member of the famous brewing family, took the world land speed record at Brooklands driving a 350 hp Sunbeam powered by a V12 18-litre Manitou aero engine at a speed of 133.75 mph. If the initials seem familiar, he designed a greatly improved spark plug that was marketed under the name KLG. The car was purchased by Malcolm Campbell, who called it *Blue Bird* and set two land speed records including 150.76 mph at Pendine Sands in 1925. A new V12 Sunbeam was built for Henry Segrave initially called Ladybird, possibly to reflect the intense rivalry with Malcolm Campbell and *Blue Bird*. In 1926 it propelled Segrave to 152.33 mph at Southport. The race was now on between these two great names to break the elusive 200 mph barrier.

By 1927, Sunbeam had built a 1,000 hp (actually nearer 900 hp) car to exceed 200 mph designed by Captain J. S. Irving. Named *Mystery*, it very quickly acquired the nickname 'The Slug' due to its aerodynamic shape. It was certainly no slug once the twin Matebele V12 aero engines were opened up. The record-breaking attempt took place at Daytona

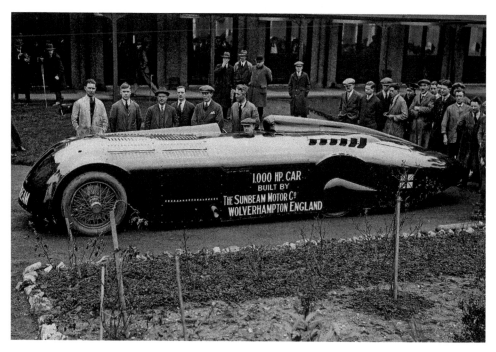

Sunbeam Mystery nicknamed 'The Slug'. (Contributor: Alamy Stock Photos)

Beach on 29 March 1927. Despite nearly crashing and having to use the sea to slow down, the average of the two qualifying runs was 203.792 mph. Henry Segrave (later to be knighted) had finally broken the 200 mph barrier and returned in triumph to Wolverhampton where he was presented with a floral miniature of the car. Within months the record would be reclaimed by arch-rival Malcolm Campbell. Despite trying again in 1930 with *Silver Bullet*, Sunbeam would never again hold the world land speed record.

DID YOU KNOW?
John Marston registered the name Sunbeam in 1888 for his new bicycle manufacturing venture at his existing japanning works in Wolverhampton. It was John's wife Ellen who came up with the name after seeing sunlight glinting off a newly enamelled bicycle frame. She said it looked just like a sunbeam. The factory would become known as Sunbeamland.

Castlefields Mine

If the name Castlefields Mine is not immediately obvious to Dudley residents and visitors, then the area above it certainly will be. Castlefields Mine was one of a number of major limestone workings in the Black Country. As well as extensive workings in

Dudley, limestone was also mined in areas such as Wednesbury and Walsall. The value of limestone has been known since at least Roman times particularly for lime mortar in building construction and later as a fertiliser. During the Industrial Revolution, many industries made use of limestone but in particular it was employed as a flux to remove impurities during the ironmaking process.

The limestone workings under Castle Hill and Mons Hill in Dudley are fairly well known. Indeed, Dudley Canal and Tunnel Trust run narrowboat trips through part of the underground network of canals and limestone caverns. The largest limestone cavern in Britain was in Dudley, known as Dark Cavern. It was here in 1839 that famed geologist Sir Roderick Murchison lectured and launched his seminal book *The Silurian System* to an audience said to have numbered 15,000 people. Lord Dudley had the cavern lit by gas lights and even arranged for underground fireworks! Once an early tourist attraction featuring popular underground concerts it is sadly no longer accessible.

During the 1984–85 season, Dudley Town Football Club was riding high. After winning the Southern League Midland Division Championship they had been promoted to the Premier Division above. The ground itself was a fitting compliment to the team with its refurbished 1,800-seater stand and flood lighting. Next door, also on the Dudley Sports Centre site, Dudley Cricket Team were doing equally well topping the Birmingham and District Cricket League, formed in 1888 and the oldest in the country. All this was to suddenly change in May 1985. The Sports Centre had always suffered from subsidence, so much so that notices warned spectators they entered at their own risk!

Dudley Town Football Club and Cricket Ground seen from the air above Burnt Tree in 1950. (Copyright Historic England)

Castle Fields Mine limestone workings.

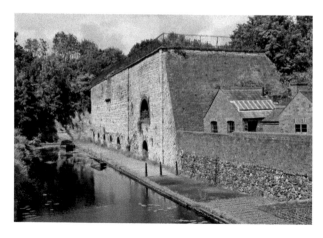

Original limekilns at the Black Country Living Museum.

The problem was the Castlefields Limestone Mine beneath. In its heyday this was reputedly the most extensive in Dudley. It had been worked by the Earl of Dudley from 1845 to 1910 using the pillar and room method of extracting the limestone. A horizontal series of rooms were dug out leaving pillars of limestone to support the roof. Over time the pillars had eroded through water seepage causing collapses and ground subsidence. On 25 May, shortly before a Birmingham League match was about to start, a large depression appeared on the cricket pitch, which later turned into a 40-foot-wide hole down into the mine below. The whole of the Dudley Sports Centre was subsequently closed, never to reopen again.

Since then, the Castlefields Mine has been successfully infilled with rock paste, basically a mix of colliery spoil and water. With a slight name change the old Sports Centre site is now a complex of restaurants, cinema, hotel and offices. Castlefields has now become the popular Castlegate Business and Leisure Park.

5. That's Entertainment

Three Men in a Boat

Best remembered for *Three Men in a Boat (to Say Nothing of the Dog)*, set on the River Thames, Jerome K. Jerome is not often associated with the Black Country. In fact, Jerome Klapka Jerome was born in Walsall on 2 May 1859, except 'Klapka' was not the name he was christened with. His parents Jerome and Marguerite Clapp had moved from Appledore in 1855 to a comfortable residence in Bradford Street, Walsall. His father was something of an entrepreneur and also a Nonconformist preacher. On moving to Walsall, he took the opportunity to change the family surname to Jerome. As 'the clap' was a slang term for gonorrhoea, it is easy to see why he would want to change it! When Jerome was born in 1859, he was registered as Jerome Clapp Jerome, the same name as his father, which was not uncommon in those days. Jerome Sr had invested heavily in a coal mine, which proved disastrous. By 1861 the family had moved to modest accommodation at No. 23 Lichfield Street and then to Worcester Road, Stourbridge. From there they moved to the East End of London and a life far removed from middle-class Bradford Street. Jerome Jr left school aged fourteen and began a succession of jobs.

Belsize House. Birthplace of Jerome K. Jerome in Bradford Street, Walsall.

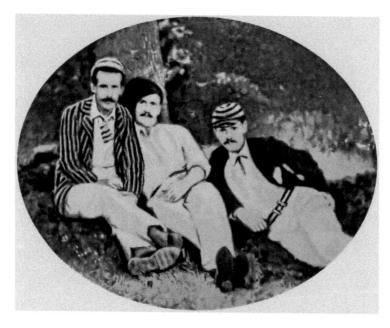

The three men in a boat were Carl Hentschel (Harris in the book) on the left, George Wingrave, and Jerome K. Jerome himself. (Contributor: Alamy Stock Photos)

By 1875 the young Jerome had lost both of his parents and at some point followed his father in changing his name. The census of 1881 records that Jerome Klapka Jerome was working as a shorthand writer to a solicitor. The year might be significant as he had reached twenty-one, the age of majority, and may have used this fact to change his name to better reflect his developing literary career. He always maintained that he was named after the Hungarian General Klapka, who had written his memoirs as a guest at their family home in Appledore. This seems to be pure whimsy on Jerome K. Jerome's part as he was actually named Clapp after his father.

After a series of jobs including journalist and actor, his first book, *On the Stage and Off*, was published in 1885. Many plays, articles and books followed including his humorous classic *Three Men in a Boat (to Say Nothing of the Dog)*, published in 1889. Jerome K. Jerome was not forgotten by his birthplace as he was made a Freeman of the Borough of Walsall in 1927. He died just a few months later that same year.

Little Liar!

The oddly named Black Patch was home to a community of Gypsies during the nineteenth and very early twentieth centuries. Despite believing they had a legal right to Black Patch there were evictions in 1905 and 1909 and plans to develop the land. Now preserved as Black Patch Park, it most likely got its name from the black furnace waste dumped there from Matthew Boulton's foundries. More recently, evidence has come to light that Charlie Chaplin came from a gypsy family and may have been born in a caravan on Black Patch.

In 1991 Charlie Chaplin's daughter, Victoria, inherited a bureau belonging to her father. One of the drawers was locked with no key to be found. When a locksmith was able to open the drawer, it revealed an intriguing secret. It contained a letter sent by someone called Jack Hill from Tamworth. In the letter Jack claims that Chaplin was a 'little liar' for

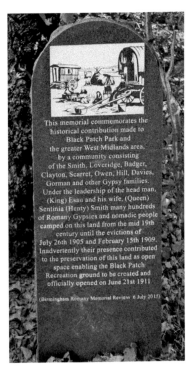

Above left: Charlie Chaplin as The Tramp in 1915. (Contributor: Alamy Stock Photos)

Above right: Memorial to the Romany Gypsies of Black Patch Park.

claiming in his autobiography that he was born in London. Jack goes on to say, 'you were born in a caravan and so was I. It was a good one it belonged to the Gypsy Queen who was my auntie you were born on the Black Patch in Smethwick'. That Charlie Chaplin had kept the letter securely locked away suggests that he had put some personal value on it.

Charlie Chaplin's mother, Hannah Hill, was a music hall singer with Gypsy family connections. According to Charlie himself his grandmother, Mary Ann Smith (Terry), was at least half Gypsy. Smith seems to have been the family name before Mary Ann's mother got married. There were both Hill and Smith families on Black Patch recorded in the 1901 census and would most likely have been there at the time of Charlie Chaplin's birth in 1889. Was Hannah in the area and staying with family members for the birth?

Esau and his wife Sentinia (Henty) Smith were the undisputed King and Queen of the Gypsies on Black Patch at that time. Esau died in 1901 and was survived by Queen Henty, as she was known, until she also passed away in 1907. Both are buried and commemorated in St Mary's Church, Handsworth. Was Henty Smith the Gypsy Queen who allowed her caravan to be used for the birth of Charlie Chaplin? These questions may never be answered as no birth certificate confirming Charlie Chaplin's real place of birth has ever been discovered. A plaque commemorating the Romany Gypsies of Black Patch Park, including the Hill and Smith families, was unveiled in 2015 by a very special guest, Charlie Chaplin's son Michael.

Buffalo Bill in the Black Country

William F. Cody, 'Buffalo Bill', brought his famous wild west show to Dudley and Wolverhampton in 1903, followed by Walsall and Wollaston in 1904. In a triumph of logistics, three special trains carried a cosmopolitan cast of some 800 performers, 500 horses and all the equipment needed to stage the shows. Cheering crowds would line the route to the show ground to watch the grand procession from the railway station. When the Wild West Show came to Wollaston in April 1904 it was Buffalo Bill's final performance in the Black Country.

William Cody was the consummate showman, and *Buffalo Bill's Wild West and Congress of Rough Riders of the World* was essentially a western-themed circus show. It was mainly the reputation of Cody himself as a former Pony Express rider, buffalo hunter and army scout that made the show such a success. The popularity of American dime novels by authors such as Ned Buntline helped to sensationalise Buffalo Bill into an American legend and created an unrealistic representation of the old west.

When Buffalo Bill brought his show to Dudley it was memorable for the fact that he was robbed of his jewellery during one of the performances. The jewellery was not just valuable but included items presented to him by royalty including King Edward VII. The thief was not a local miscreant but Buffalo Bill's own valet who was caught after posting the jewellery to his sister in London. She turned it in to the police and the game was up. The young valet was tried in Dudley and sentenced to six months' hard labour.

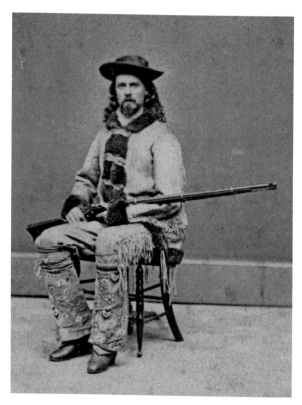

William F. Cody 'Buffalo Bill'. (From The New York Public Library)

Around the same time wild west showman Samuel Franklyn Cowdery was touring the theatres with his production of The Klondyke Nugget. Cowdery styled himself on Buffalo Bill and even used the name Colonel Cody. The confusion he deliberately created was such that many people believed they were one and the same person. Apart from theatre, Cody's main interest was flight. Wolverhampton Star Theatre manager Colin Hazlewood recalled how during the day Cody would have his troupe helping to build his experimental man-lifting kites. According to Hazlewood, while in the Black country Cody would 'fly his huge kites over the pit banks between Wolverhampton and Bilston'. He would go on to build a powered flying machine called the British Army Aeroplane No. 1A. Samuel Cody would become known in his own right for the first British powered flight at Farnborough Common on 16 October 1908.

Back in the Limelight

The little Limelight Cinema in Vine Street, Hartshill, closed its doors in 1929. Thanks to a remarkable discovery over fifty years later by local author Ned Williams, the cinema has been preserved and continues to delight present-day audiences.

The cinema was built by John Revill, who had started off by showing silent films to entertain his family and friends after the First World War. He went on to build a small commercial cinema on land next to his house and show films to the general public. Having obtained a licence for 'Kinematograph Exhibition' from Dudley Council, the cinema opened in 1921. It was very much a family affair. John even printed his own stationery and handbills. His wife, Mary, sold tickets from a separate wooden pay booth outside. His daughters, Violet and Maud, would operate the wind-up gramophone, choosing appropriate records to play with the black and white films projected by John and his nephew Leslie Ball. For a small, backstreet cinema it was very successful showing films

John Revill's daughter Maud and Ned Williams outside the Limelight Cinema in Hartshill. (Courtesy of the Ned Williams Collection)

The Limelight Cinema
at the Black Country
Living Museum.

Inside the restored
Limelight Cinema.

such as silent comedies, westerns and melodramas. John and his nephew even enlarged it in 1926 to add more comfortable tip-up seats at the back and newer projectors with carbon arc lamps requiring an electricity supply generated from his own gas-powered engines.

The cinema operated successfully until 1929 when John started to lose money and took the decision to close it. The 'talkies' had arrived in 1927 with *The Jazz Singer* and the equipment required for sound films was well beyond the means of such a small backstreet cinema. Also, big plush cinemas had opened in nearby Dudley and Brierley Hill, which proved to be just too much competition. When he closed it, John left virtually everything in place including the screen and the projectors, although he did use the building itself for other purposes such as the breeding of tropical fish.

After John's death in 1965 the cinema had remained locked up and forgotten about. In 1982 it was rediscovered by local author Ned Williams just before the land, together

with the cinema, was sold to William Round (Transport) Ltd by John's daughter Maud. Remarkably, much of the old cinema was still intact. By 1993 when Rounds wanted to redevelop the site, arrangements were made to move the historic cinema brick by brick to the Black Country Living Museum. Here, the old cinema is back in the limelight, continuing to entertain visitors with classic black and white silent movies.

James Whale

The name may not be familiar but some of his now classic films certainly will be. James Whale was born to a hardworking Dudley family in 1889, the sixth of seven children. His father was a blast furnaceman and his mother a nurse. The young James was educated at Kates Hill Board School, Baylies' Charity School and Dudley Blue Coat School before starting work aged fourteen. Never a physically strong lad, he was unsuited to heavy industry and went to work for a local cobbler. Having a natural artistic ability, he made extra money for himself sign writing, which he used to pay for night classes at the Dudley School of Art.

Movie poster for James Whale's *Frankenstein*. (Contributor: Alamy Stock Photos)

Memorial to James Whale near Castlegate Way in Dudley.

The big turning point in James Whale's life came during the First World War. Seeing conscription coming he enlisted, and despite his background was commissioned as a second lieutenant in the Worcestershire Regiment. In 1917, during an assault on German lines he was captured and spent the rest of the war in Holzminden POW camp in Lower Saxony. Here he discovered a keen interest and ability in directing theatrical entertainments for his fellow prisoners. The die was cast and after being released Whale embarked on a career in the theatre, firstly with the Birmingham Repertory Company and later moving to London. His big break as a director came in 1928 and ironically drew upon his experiences in the trenches. *Journey's End* was an unexpected hit with theatregoers and starred a young Laurence Olivier. After a run in the West End, Whale was invited to produce the play on New York's Broadway. This proved to be his gateway to Hollywood and stage experience was a valuable commodity with the advent of the new 'talking' pictures. Initially a dialogue director, Whale was soon asked to direct the film version of *Journey's End*, which was released in 1930. By now under contract with Universal Pictures, his second film for them would establish his reputation as a major director. In an inspired piece of Hollywood casting, Whale employed British actor William Henry Pratt to play the part of the Monster in *Frankenstein*. His screen name was Boris Karloff. Although Whale directed films in different genres, including the popular musical *Show Boat* (1936) with Irene Dunne, Paul Robeson, and Allan Jones, it is his four horror films that have become movie classics. As well as *Frankenstein* (1931), he directed *The Old Dark House* (1932), *The Invisible Man* (1933) and the *Bride of Frankenstein* (1935).

Whale's career as a director went into decline after he fell out with Universal over *The Road Back* (1937). This was intended as a sequel to *All Quiet on the Western Front* but Universal succumbed to German pressure and the original screenplay was changed. After this Whale's career was waning and he retired after producing an army training film in 1942. Whale suffered two strokes in 1956 and in May 1957 was found dead in his

swimming pool. He was sixty-seven. Initially considered accidental, a suicide note came to light later shortly before the death of his long-term companion David Lewis. In the note Whale wrote that he had enjoyed 'a wonderful life'. From working-class Black Country lad to top Hollywood film director, James Whale had certainly enjoyed an incredible life.

Theatre of Dreams

David Harrison's definitive book *Theatre of Dreams* is a perfect description of what the Dudley Hippodrome once was. The sorry shell that the exterior has become gives little hint of the wonderful art deco interior, which welcomed theatregoers and attracted many of the biggest stars of the day. Dudley Hippodrome was designed by architect Archibald Hurley Robinson for Ben Kennedy and would be managed by his sons Bob and Maurice. The new theatre resembled a large art deco cinema with its buff brick frontage. It fitted in very well with the now demolished Plaza cinema next door and the former Odeon cinema almost opposite, which is still in existence. With seating for around 1,750 patrons in the fan-shaped auditorium, the new Hippodrome boasted the largest stage with the most up-to-date scene shifting and lighting equipment of any theatre in the Midlands at that time. Construction was completed in just sixteen months and the theatre opened with a band concert on 19 December 1938.

The list of big-name stars who played at the Hippodrome reads like a who's who of the entertainment industry. Laurel and Hardy appeared at the Hippodrome in 1947 and 1952. As with many of the big stars who performed there, they stayed at the Station Hotel opposite, which has a reputation for being haunted, although not by old troupers as far as is known. For the 2018 feature film *Stan and Ollie* starring by Steve Coogan and John C. Reilly, some of the filming took place at the nearby Black Country Living Museum. On 22 April 1957 Bob Hope did two shows at the Hippodrome. He was in good company.

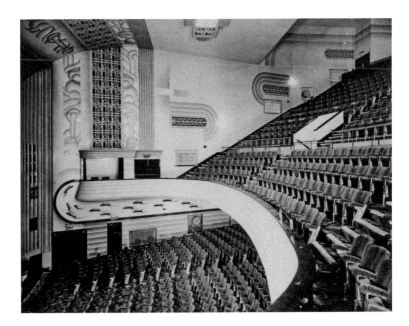

Dudley Hippodrome in its heyday. (Courtesy of the Ned Williams Collection)

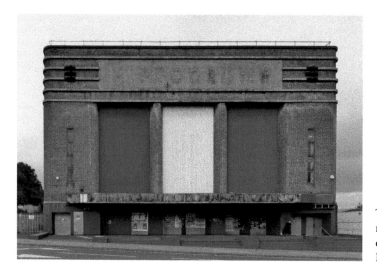

The now much-neglected exterior of Dudley's Hippodrome.

Among the endless list of stars who performed there are household names such as George Formby, Tommy Cooper, Harry Secombe, Dame Vera Lynn, Morecambe and Wise, Cliff Richard, Ken Dodd and so many others. Apart from all the variety shows, plays and musicals it is perhaps the pantomimes that are most fondly recalled by those old enough to remember them.

In 1958 the Kennedy brothers ended their association with the Hippodrome. The theatre was in gradual decline and suffering mixed fortunes, partly due to television and the astronomical fees stars were now demanding coupled with crippling rental costs imposed by the trustees of Ben Kennedy's estate. The very last theatre production was Ivor Novello's *Glamourous Nights*, performed by the West Bromwich Operatic Society on 29 February 1964. The building was taken over as a casino and then a bingo hall but even this closed in 2009.

At the time of writing the Hippodrome's future is in doubt, despite the best efforts of dedicated campaigners to restore Dudley's art deco theatre back to the premier entertainment venue it once was. A much-loved Black Country theatrical tradition looks set to end if the curtain finally falls on Dudley's historic Hippodrome.

DID YOU KNOW?
Dudley Hippodrome was the second theatre to be built on the Castle Hill site in Dudley. The first was the Opera House, which opened in September 1899. One claim to fame for the Opera House was that a young Charlie Chaplin appeared there in 1906. Another young performer was Arthur Stanley Jefferson who became better known as Stan Laurel. Disaster came to the Opera House in the early hours of 1 November 1936 when a raging fire destroyed the building despite the best efforts of the local fire brigade.

Madeleine Carroll

The name may not be familiar these days, but Madeleine Carroll was an international movie actress who swapped Hollywood stardom for humanitarian service at the height of her fame. Edith Madeleine Carroll (Marie-Madeleine Bernadette O'Carroll) was born in Herbert Street, West Bromwich, on 26 February 1906. Her mother was French and her Irish father a teacher of modern languages. Madeleine was encouraged academically and was expected to follow her father into a teaching career after earning a BA in modern languages at the University of Birmingham in 1926. This was not to be. While at the university a leading role in the annual play set Madeleine off on an entirely different path.

After a short period of teaching Madeleine followed her dream to act. Initially struggling with failed auditions, and having to model hats, she landed a part in the West End production of *The Lash*. This was the turning point and film offers soon followed making Madeleine Carroll, a British film star. Following a year-long absence after her first of four marriages, she returned to the silver screen with popular films in Britain and a less than successful spell in Hollywood. On returning to Britain, Alfred Hitchcock cast Madeleine opposite Robert Donat in her best-known film *The 39 Nine Steps*. Allegedly, after the first scene was shot Hitchcock left the pair handcuffed together to get better acquainted and develop their on-screen chemistry! Following this success, she became one of Hollywood's highest earning actresses going on to make over forty films in her career.

Madeleine Carroll pictured in 1937.
(Contributor: Alamy Stock Photos)

Memorial to Madeleine Carroll in West Bromwich Town Centre.

Tragedy struck in 1940 when Madeleine's younger sister, Marguerite, was killed in the London blitz. This led Madeleine to become increasingly concerned with the war in Europe and in the same year had already turned her French chateau into an orphanage. Madeleine's last big film was the comedy *My Favourite Blonde* with Bob Hope in 1942. Turning her back on Hollywood in 1943, she threw herself into the war effort joining the Red Cross as a nursing orderly under the name of Madeleine Hamilton. In 1944 she was attached to the 61st Field Hospital based in Italy where wounded American airmen from bases around Foggia could find themselves being nursed by a world-famous Hollywood movie star. After the war Madeleine continued with humanitarian work especially helping to relieve the plight of displaced and war-orphaned children as an ambassador for UNICEF.

Madeleine Carroll was awarded both the American Medal of Freedom and the French Legion of Honour for her humanitarian work during the Second World War. She died in 1987 and was buried in Spain. Apart from commemorative plaques, there was no local memorial to the famous actress and humanitarian. Mainly due to the sterling efforts of the late Terry Price, a local historian and author, a fitting tribute was finally unveiled on 21 February 2007 in Madeleine Carroll's home town of West Bromwich.

Back to Bilston

In 2013 *Back to the Future* film fans flocked to the DeLorean Time Machine exhibit at Birmingham NEC's Comic Con. Filmed mainly at the Universal Studios in Hollywood, a lesser-known fact is that the iconic car had a connection with the Black Country.

DeLorean cars were assembled at a factory in Dunmurry near Belfast in Northern Ireland, but many of the components were sourced from elsewhere. One vitally important part of the car was its three-part chassis, and this was manufactured by GKN Sankey in

GKN Sankey workers get to see a DeLorean in April 1981. (Courtesy of Shropshire Star Pictures From the Past)

Bilston. Originally known as the DMC-12, John DeLorean's sports car, with its distinctive gull wing doors, had a relatively short lifespan after the company went into liquidation, and the very last cars left the production line in 1983.

Only around 9,000 DeLoreans, as they were later known, were ever produced but six of these were to become famous through the now classic *Back to the Future* trilogy of films. The first *Back to the Future* was released in 1985 and starred Michael J. Fox as Marty McFly and Christopher Lloyd as the inventor of the DeLorean-powered time machine itself Doctor Emmett Brown.

DID YOU KNOW?
It was said of Joseph Sankey & Sons that, 'If it was made out of metal, they made it.' Even so, who would have thought they helped to build a time machine in Bilston. Great Scott!

The Real Aeronauts

A Wolverhampton gasworks might seem an unlikely location for a world altitude record. For Dr James Glaisher and Henry Coxwell in 1862 it made perfect sense. Henry Coxwell was the pilot and designer of the gas-filled balloon named Mammoth. Stafford Road gasworks provided a lighter version of coal or town gas in a gasometer to fuel three high altitude scientific balloon ascents. The Black Country was a perfect location given its distance from the coast in any direction, thus minimising the danger of drifting out to sea and almost certain death. The third ascent on 5 September 1862 would not only set a world altitude record but also inspired the 2019 film *The Aeronauts* featuring James Glaisher and Amelia Wren. Unfortunately, the film does not let history get in the way of a good story being set in London rather than Wolverhampton. Amelia Wren is a fictional character and replaced the actual hero of the day, Henry Coxwell.

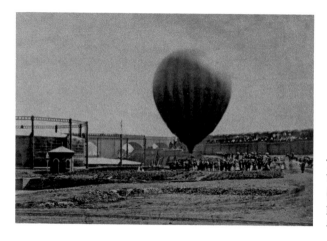

The record-breaking
Wolverhampton balloon ascent.
(Image reproduced with the
permission of Wolverhampton
Archives & Local Studies)

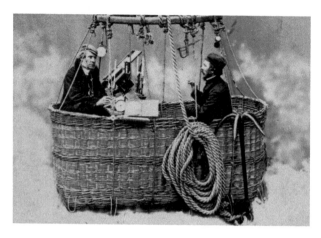

Glaisher and Coxwell. (Courtesy
of Rijksmuseum)

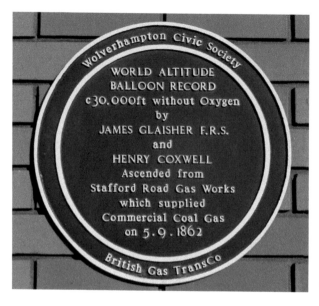

Commemorative plaque on the
site of the former Stafford Road
Gas Works at the University of
Wolverhampton Science Park.

The flight from Wolverhampton was one of a number financed by the British Association for the Advancement of Science. The basket of the balloon was packed with scientific instruments for making meteorological measurements, which was the principal purpose of the high-altitude flight. According to Glaisher's own account in his 1871 book *Travels in the Air*, Mammoth lifted off from Stafford Road gasworks at 1.03 p.m. Breaking through the clouds at over 6,000 feet Glaisher attempted what may have been the first ever aerial photograph above the clouds. Unfortunately, as Glaisher himself noted, the balloon was 'rising with too great rapidity and revolving too quickly to enable me to succeed'. Glaisher and Coxwell were woefully ill equipped for the extremes of cold and lack of oxygen at high altitude. Glaisher made his last altitude measurement at just over 29,000 feet (5.5 miles) above the earth before passing out. The balloon continued to ascend and Coxwell knew he had to pull the gas release valve or they would both die. By now Coxwell's hands were frozen and black through lack of oxygen. Having struggled up into the rigging he didn't have the strength in his fingers to pull the release cord. The situation was only saved when Coxwell had the presence of mind to pull the cord two or three times with his teeth. As they now descended Glaisher regained consciousness and they eventually made a safe landing at Cold Weston, just over 7 miles from Ludlow. Glaisher's own estimate is that they reached a height of 37,000 feet (7 miles). Modern jetliners typically fly at 36,000 feet. They were incredibly fortunate to have survived and to be capable of walking the 7 or so miles to the nearest pub for a drink and a meal!

Although Amelia Wren is fictional, the character is at least based on intrepid female aeronauts. One such was Sophie Blanchard. The French widow of an aeronaut, she would launch fireworks from the air to entertain the crowds before being killed in a ballooning accident in 1819. Another was Margaret Graham, who made her first solo flight in 1826 and claimed to be Britain's first female aeronaut. Mrs Graham, as she billed herself, did in fact perform daring balloon flights over London as featured in the film.

DID YOU KNOW?
The first flight in the Black Country of a powered lighter than air machine took place on 7 August 1905 during a fête at the Corbett Hospital grounds in Stourbridge. Stanley Spencer had been invited to demonstrate his engine-powered gas-filled airship. According to a newspaper report of the time, the first flight took place at 6.30 p.m. and the airship headed off towards Brierley Hill before encountering a thunderstorm. Fortunately, Spencer was able to make a controlled landing on the golf links at Scott's Green.

6. The American Connection

Lawrence and Cassandra Southwick

Puritans who fled to the New World to avoid religious persecution could in turn become persecutors themselves. This was certainly the experience of the Southwick family who originated from Kingswinford. Lawrence and Cassandra Southwick had married in Kingswinford around 1623. Lawrence was a glassmaker, an industry which had grown up in and around the Stourbridge area in the early seventeenth century. This was mainly due to the ready availability of coal but also fire clay for furnaces and melting pots. When King James I issued a proclamation in 1615 forbidding the use of charcoal for glass production, glassmaking began to expand in the area. At this time, the output was mainly window glass and bottles, a valuable skill for Lawrence to possess.

Lawrence and Cassandra Southwick and four children, John, Mary, Josiah and Provided, emigrated to the New World sometime between 1635, when a baptism record for Provided shows them being in Kingswinford, and 1637 when Daniel was born in Salem. In 1639 they were admitted to the First Church in Salem, Massachusetts. In 1640 Provided died aged five, but in 1641 another daughter was born also called Provided. In Salem, Lawrence Southwick began glass making, becoming one of the first in America to do so. By 1642 though he had turned to farming. The notorious Salem witch trials of 1692 and 1693 are well known but less so is the earlier persecution of those regarded as heretics.

It is difficult to determine exactly when the Southwick's became Quakers, but their persecution appears to have begun around 1656 when Cassandra was arrested for absence from worship. Quakers were regarded as heretics and severe punishments were commonplace around this time including imprisonment, whipping or worse. In 1657,

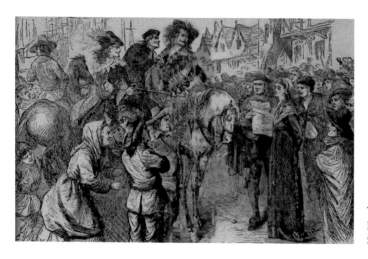

The attempted sale of Daniel and Provided Southwick into slavery.

Lawrence and Cassandra were sent to prison and fined by Governor John Endicott for entertaining two strangers, presumably Quakers, and being in possession of a paper regarded as heretical. Lawrence was released to be dealt with by the congregation of First Church, but Cassandra was imprisoned for seven weeks. In 1658, Lawrence, Cassandra and their son Josiah were imprisoned at Boston for twenty weeks for being Quakers and subsequently banished on pain of death if they returned. In 1659 they fled to Shelter Island, New York, and the protection of estate owner Nathaniel Sylvester. Both Lawrence and Cassandra died within days of each other on Shelter Island in the spring of 1660. A monument dedicated to Nathaniel Sylvester was unveiled in 1884. On the steps leading up to the monument are the names of Quakers he sheltered including a poignant reminder of what the Southwick's endured:

Lawrence and Cassandra Southwick
Despoiled Starved Whipped Banished
Who fled here to die.

In 1659 two of the Southwick's children, daughter Provided and son Daniel, were fined for their association with Quakers. When the fine went unpaid both were ordered to be sold into slavery in Virginia or Barbados. To their credit, no sea captain would agree to take them, especially the nineteen-year-old Provided. The sentence was thankfully never carried out. Rather fittingly, direct descendants of the Southwick family, Joseph and Thankful Southwick and their daughter Sarah, would later become prominent anti-slavery campaigners.

DID YOU KNOW?
One of the first Quaker Meeting Houses in the country, built shortly after the Act of Toleration in May 1689, is hidden away just off the ring road in Stourbridge. The Act allowed for freedom of worship but only for Protestant Nonconformists including Quakers. The Grade II listed Friends Meeting House is rare in the Black Country for a building of this age because after over 330 years it is still being used for its original purpose.

Button Gwinnett

Amongst the world's most valuable signatures you would expect to instantly recognise the names. Not so with Button Gwinnett. Born in 1735 at Down Hatherley in Gloucestershire, where his father was rector, he was named after his godmother Barbara Button. Gwinnett is known to have worked with his uncle, a Bristol merchant, before moving to Wolverhampton. Here he met his future wife, Ann Bourne, and they were married in 1757 at St Peter's Church. They had three children together, Amelia, Ann, and Elizabeth Ann. Like his uncle, Gwinnett was involved in trade with America and emigrated to

Button Gwinnett. (From The New York Public Library)

The ill-fated duel with General McIntosh. (From The New York Public Library)

Button Gwinnett's valuable signature. (From The New York Public Library)

Savannah in Georgia around 1765. After keeping a store, he leased St Catherine's Island and became a planter. As a businessman he seems to have been beset by debt, which may have prompted his entry into local politics.

The War of Independence (1775–83) saw Gwinnett firmly on the side of separation from Great Britain. He had ambitions to command Georgia's Continental Battalion but was forced to accede to Colonel (later General) Lachlan McIntosh, initiating a feud which would ultimately lead to Gwinnett's downfall. Instead, he was appointed to the Continental Congress in Philadelphia at a pivotal time in America's history. On his return, Button Gwinnett was elected Commander-in-Chief and President of Georgia on the death of Archibald Bulloch. He proposed an ill-fated expedition against the British in East Florida. This brought him into direct conflict with Lachlan McIntosh over control of the expedition forces. After Gwinnett failed to be elected Governor of Georgia, things came to a head when he was acquitted of any blame over the failed East Florida campaign. A furious McIntosh publicly called Gwinnett 'a Scoundrel and lying Rascal'.

Gwinnett's answer was to challenge General McIntosh to a duel. They met at dawn with their seconds and fired duelling pistols from a distance of about 12 feet. Both men were wounded in the thigh and honour was satisfied. McIntosh recovered from his wound but Gwinnett died three days later on 9 May 1777 after his wound turned gangrenous.

Had Button Gwinnett got his wish and commanded Georgia's Continental Battalion he would no doubt have slipped into obscurity. As it was, he was in Philadelphia at the right time to add his signature to the Declaration of Independence. Of the fifty-six men who signed the Declaration, Button Gwinnett's signature is the most valuable because he left few signed documents. There are only fifty-one known examples in the world. In 2010 a Gwinnett signature sold for $600,000, nearly half a million pounds. Ironic that after a life spent mainly in debt, Button Gwinnett's signature should now be worth so much.

DID YOU KNOW?
John (Iron Mad) Wilkinson developed a means of accurately boring cast-iron cannons. His great innovation was to rotate the cannon rather than the drill or boring bar thereby ensuring extreme accuracy. During the American War of Independence Wilkinson was a major supplier of cannon to the Royal Navy. When Wilkinson's boring technology was applied to cylinders it enabled Boulton and Watt's steam engines to power the Industrial Revolution.

When in Doubt, Use Caslon

There cannot be many things developed in the eighteenth century that can still be found in a modern personal computer. One notable exception is the Caslon typeface first designed in 1722. Most sources agree that William Caslon was born at Cradley in 1692 but he may have been baptised at nearby Halesowen in 1693. Although undoubtedly Black Country born and bred, Caslon spent most of his life living in London. By the age of thirteen he

William Caslon. (Copyright the Trustees of the British Museum)

William Caslon's 1734 Specimen Stylesheet. (Copyright Paul Balluff)

was apprenticed in London to an engraver of quality firearms. His connection with the printing industry came through working as a tool cutter for artisan bookbinders. By 1716 Caslon had his own engraving and tool-making business and his innate skill did not go unnoticed by prominent London printers. He was financed to set up a type foundry and in 1720 produced his first typeface for the New Testament in Arabic.

Although 1722 is often quoted as the date of designing his Caslon typeface, its initial use is thought to have been 1726 with the first of several books produced for one of his patrons, the printer William Bowyer. It was immediately popular being an English alternative to the mainly Dutch-styled typefaces of the time. It was Caslon's 1734 specimen sheet featuring Roman and italic typefaces in fourteen sizes that ensured his was the typeface of choice for printers in Britain, on the Continent, and in the Colonies. Within the later Arts and Crafts Movement, synonymous with Birmingham, a popular motto for designers and printers was 'When in doubt, use Caslon'. The type foundry passed from William Caslon the elder to William Caslon the younger. The company founded by William Caslon has diversified but continues to this day in St Albans, with a member of the Caslon family still in charge as Managing Director.

William Caslon provides yet another intriguing link between the Black Country and the American Declaration of Independence. When John Dunlap was tasked with printing the historic 'Dunlap Broadside' on the night of 4 July 1776, the predominant typeface used for the Declaration was from the type foundry of William Caslon, letter founder to the King. The same King George III of course that the document was declaring independence from!

DID YOU KNOW?
Black Country-born William Caslon and his typefaces inspired Birmingham based typefounder John Baskerville. His Baskerville typeface designed in 1757 improved the legibility of Caslon's earlier typefaces and is still a popular font family to this day.

7. War and the Black Country

Ancient Rivalry

'Black Country boys and Brummie boys are on the same side again,' said Tommy. 'That'll be the bloody day,' replied John. So went a conversation between two of the Shelby brothers in the hugely popular *Peaky Blinders* television series written by Steven Knight. The series is based in Birmingham, but many scenes are shot at the Black Country Living Museum. Although modern, this exchange typifies the not-so-secret rivalry that has long existed between the Black Country and Birmingham. When and how this came about though is a bit more obscure. One thing is certain, there is nothing more likely to start a heated debate in the Black Country than to ask for an opinion on exactly where it is. Turn the question around to ask where it is not, and the answer will invariably be Birmingham!

One area in which rivalry has long exhibited itself is on the football pitch, between the Black Country's West Bromwich Albion and Birmingham neighbour Aston Villa. West Bromwich Albion was formed in 1878 by workers from George Salter's Spring Factory. The fan's chant of 'Boing Boing' is pure coincidence! In 1887 they reached the final of the FA Cup but lost out to Aston Villa. In the 1892 FA cup final Albion turned the tables with a win against the Villa. Albion's other great local rivals, Wolverhampton Wanderers, won the FA Cup the following year against Everton.

The fact that the Black Country has its own distinct dialect is one thing that sets it apart from Birmingham, but even so the two areas share long established links. One of these came in 1769 when the first shipment of coal from the Black Country to Birmingham arrived by canal. This had been 'cut' by James Brindley and completed in 1772. The lack of raw materials and navigable rivers had prompted Birmingham industrialists including Matthew Boulton to get Parliament's approval for this first canal. In 1824 Thomas Telford

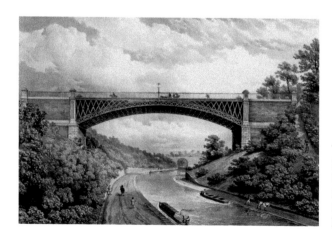

Thomas Telford's Galton Bridge in Smethwick spanning Birmingham Canal Navigation's New Main Line. (Photo by Birmingham Museums Trust, licensed under CC0)

was appointed to improve Brindley's Old Main Line and cut his New Main Line from Gas Street Basin straight through to Tipton. If there was ever such thing as a motorway between Birmingham and the Black Country in the 1800s this canal was it. Manufacturing links flourished such as Birmingham's gun trade, which relied on gunlocks and barrels manufactured in places such as Wednesbury and Darlaston.

Back in the days of the English Civil War Birmingham was fiercely Parliamentarian, but Dudley Castle was a major Royalist stronghold and the Black Country produced much needed weapons for Charles I. Dudley Castle commander, Colonel Leveson, led raids on Birmingham while Edgbaston Garrison's Colonel 'Tinker' Fox raided Dudley and the Black Country. Local rivalry could even date back to the English Civil War when Birmingham was effectively at war with its Black Country neighbour.

Ace in a Day

A flying 'ace' in the Royal Air Force (RAF) is a pilot who has shot down five or more enemy aircraft in aerial combat. During the Second World War the first confirmed 'Ace in a day' went not to a Spitfire or Hurricane but to Wolverhampton's forgotten fighter: the Defiant. Boulton Paul Aircraft Ltd had completed a move from Norwich to Wolverhampton in 1936. They won a contract from the Air Ministry in the mid-1930s to produce a two-seater fighter aircraft specifically to attack bombers. This was the Defiant with its advanced rear-facing powered turret equipped with four Browning machine guns. Germany was assumed to be the enemy and fighter escorts were not even considered a possibility. In fact, during the Battle of Britain, Luftwaffe squadrons based in France would provide fighter protection to the bombers.

The Defiant, with no forward-facing armament, was never designed for dogfights with the likes of the Messerschmitt BF-109 fighter also known as the ME-109. The only saving grace, at least to start with, was that the Defiant resembled a Hawker Hurricane, albeit with a turret. Accepted wisdom was to attack Hurricanes from behind, which was clearly a mistake with the Defiant, but one which was quickly rectified by the Luftwaffe. Heavy losses against superior fighters did nothing for the Defiant's reputation, particularly in the press. After a switch to more appropriate night fighter operations, it was more

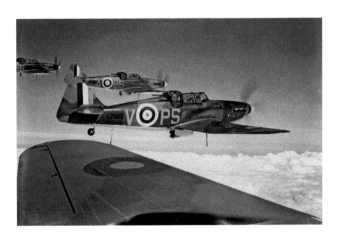

Boulton Paul Defiants of 264 Squadron RAF. (Contributor: Alamy Stock Photos)

effective against the bombers but by 1942 Defiants were only employed in non-combative roles such as sea rescue operations and as target tugs for gunnery practice.

Nevertheless, there were notable successes. On 29 May 1940, 264 Squadron flying Defiants were providing air cover as Operation Dynamo, the 'Miracle of Dunkirk', played out beneath. Over two operational sorties thirty-seven Luftwaffe aircraft were claimed with no loss to the squadron. This achievement would not be equalled throughout the war. It was during this action that Flight Lieutenant 'Lanky' Cooke and his gunner, Corporal Albert Lippett, became the first RAF crew in the Second World War to achieve the accolade of 'Ace in a day'. It was reported in the *London Gazette* that they downed 'eight enemy aircraft in the course of two patrols'. They were flying the much maligned Defiant.

In December 1941 Lord Gorell, Chairman of Boulton Paul, presented 264 Squadron with a silver salver to commemorate the downing of its 100th enemy aircraft. A fitting tribute to the Battle of Britain's forgotten fighter and the brave crews who flew the Boulton Paul Defiant.

DID YOU KNOW?
Quarry Bank had a very narrow escape during the bombing in the Second World War. On the night of 20 December 1940 two large Luftmines, or parachute mines, were dropped on the High Street. One landed behind the cinema and one crashed through the roof of the Liberal Club. Miraculously neither exploded. If they had, the devastation and loss of life would have been terrible. Both were safely defused and after narrowly escaping such destruction, Quarry Bank became known as the 'Holy City'.

Forgotten Hero

The epic Second World War film *The Great Escape* (1963), which made a star of Steve McQueen, was also linked with a now forgotten Black Country hero. Harry Aston Williams was born at Tipton in 1919 and on leaving Dudley Grammar School began a promising career in local government, which was to be interrupted in 1939 by the outbreak of the Second World War. On joining up, Harry was recruited into the RAF to train as a bomber pilot. After qualifying as Sergeant Williams, he was posted to No. 35 Squadron RAF Linton-on-Ouse in Yorkshire. When he joined the squadron in March 1941 the acting Squadron Leader at the time was Leonard Cheshire, who would later be awarded the Victoria Cross.

Due to technical difficulties with the new Handley Page Halifax bombers Harry was temporarily assigned to No. 58 Squadron. On the night of 24 July 1941, he was piloting a Whitley bomber on a raid to Emden. After taking off from Linton-on-Ouse the Whitley suddenly developed severe engine trouble and Harry tried to return to the airfield. With the plane too low for the crew to bale out, and the fully fuelled bomber rapidly losing height, Harry was left with only one option to avoid a catastrophic crash. Showing

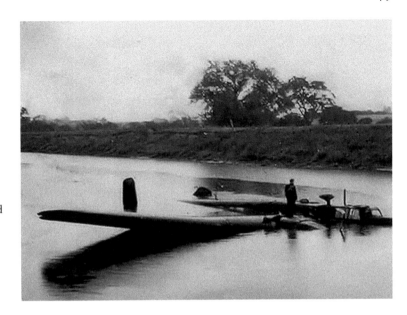

The safely ditched Whitley Bomber (T4285) in the River Ouse near Beningbrough. (Courtesy of Richard Allenby)

remarkable flying skills, Harry landed the stricken bomber safely in the River Ouse. The crew used their dinghy to evacuate the bomber assisted by Thomas Hardwick, headmaster of nearby Red House Preparatory School, who rescued some of the crew using a rather basic boat built by some of the boys in the school workshop!

Harry's first of many bombing missions as Captain of a No. 35 Squadron Halifax aircraft took place over Essen on 10 October 1941. His skill and bravery as a pilot meant that despite some narrow escapes, he never lost a crew member. In October 1941, after a successful sortie to Nuremburg Harry's plane ran out of fuel before reaching Linton-on-Ouse. Most of the crew bailed out but in doing so the pilot's parachute fell through the hatch with them. Harry managed to execute a controlled crash landing and get the remaining crew and himself out of the aircraft before it was engulfed in flames.

A veteran of some fifty raids when still only twenty-three, Sergeant Harry Williams was granted a commission in February 1942 and acquired the rank of Pilot Officer. Shortly after in March 1942 he was awarded the Distinguished Flying Medal for his heroism and service to 35 Squadron. Before his DFM could be officially presented, Harry's Halifax bomber was shot down over Holland on 2 June 1942 after a raid on Essen. To the great relief of his family and friends it later transpired that Harry, true to form, had managed to crash land his Halifax without losing of any of his crew. Harry Williams would spend the rest of the war being moved between prisoner of war camps until finally ending up at Stalag Luft III, which was mainly a POW camp for airmen.

It was while at Stalag Luft III that Harry helped in the largest mass breakout of prisoners during the Second World War. Although he was not able to escape himself, Harry was instrumental in helping many others who did. It was this event that would later become the inspiration for the film *The Great Escape*. Having survived the war, Harry Aston Williams passed away in 1984, aged sixty-four. The RAF scattered his ashes over the sea as a special tribute to this now forgotten Black Country hero.

Pilot Officer Harry Aston Williams DFM in Stalag Luft III prisoner of war camp at Sagan in the German province of Lower Silesia.

Frank Foley

Nestled in a secluded corner behind Studley Court in Mary Stevens Park sits Frank Foley, quietly feeding the birds. Living out his retirement in Stourbridge, friends and neighbours had no idea of Frank Foley's secret wartime past or his extreme heroism, which was never officially recognised until after he had passed away in 1958.

Major Frank Foley was a veteran of the First World War and a secret agent for MI6 before the Second World War. His cover was that of Passport Control Officer in Berlin, but in fact he was head of the British Secret Intelligence Service there, controlling agents and gathering intelligence for the Foreign Office.

As if this was not enough, Frank Foley set about using his position as Passport Control Officer to help Jews flee Germany supported by his wife, Kay. This was in defiance of the British Foreign Office, but Frank Foley was well aware of the fate facing Jews if they remained in Germany. Immigration was strictly controlled but Frank Foley blatantly disregarded the rules to issue over 10,000 visas enabling Jewish families to escape the Holocaust. He also entered concentration camps to issue visas to Jews imprisoned there at great personal risk to himself. Not only that, he was involved in forging passports and also hid Jews fleeing persecution in his own home. On having to leave Germany at the start of the war, Frank Foley left behind visas to be used by Jews escaping the Nazis.

These acts of extreme heroism might have been forgotten, except by the people he saved, but for the publication of Michael Smith's book *The Spy Who Saved 10,000 Jews,* published in 1999. As a result of this Major Frank Foley was officially recognised as one of the 'Righteous Among the Nations' by Israel's Yad Vashem – The World Holocaust

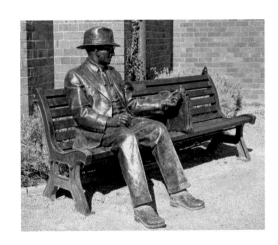

Frank Foley feeding the birds in Mary
Stevens Park, Stourbridge.

Remembrance Centre. He was also recognised as a British Hero of the Holocaust by our
own government. Frank Foley is commemorated in his birthplace at Highbridge, by MI6
in London, and in Stourbridge where he spent his retirement. The statue in Mary Stevens
Park was unveiled by His Royal Highness the Duke of Cambridge on 18 September 2018.

Major Frank Foley never sought or received any recognition during his own lifetime.
Indeed, true to his MI6 background and remaining secretive to the end, who would have
thought that the unassuming gentleman feeding the birds in Mary Stevens Park had
saved thousands more Jewish lives than even the renowned Oscar Schindler.

Himley Hall Hospital

Himley Hall is well known as the former home of the Earls of Dudley, but is now popular
for its parkland, coffee lounge and galleries. Less well known is its role during the
Second World War as a Red Cross convalescent hospital, with the Countess of Dudley its
'Commandant'.

At the start of the war (Frances) Laura Long, then Viscountess Long, was going through
a lengthy divorce and although living at Himley Hall, could not marry William Humble
Eric Ward, 3rd Earl of Dudley, but had acted as his hostess for a number of years. In
September 1939, Laura, as she liked to be known, became a nursing auxiliary at Dudley
Road Hospital in Birmingham. Laura tried to keep her real identity secret and was simply
known as Nurse Long. Unfortunately, one of the other nurses was an avid reader of
the *Tatler* society magazine and recognised some photographs of the Viscountess. The
secret was out! One concession Laura did make was to her uniform. Unimpressed with
the quality, she had it improved by a 'real dressmaker' according to her autobiography.
During the time she was nursing Laura had permission to continue living at Himley
Hall and commute to the hospital in her Hillman Minx car. The Earl at this time had
been appointed Regional Commissioner of Civil Defence for the Midlands based in
Birmingham and was instrumental in organising the recovery following the bombing
of Coventry.

In February 1943 Laura was able to marry Eric Ward to become the Countess of Dudley.
The south wing of Himley Hall became a Red Cross hospital and Laura was ideally

Himley Hall and park.

suited to oversee it as commandant together with a 'most charming' matron she called Lewis. In the early days, a group of children arrived from London to spend three weeks convalescence at Himley. Their Catford school had been bombed in the Blitz, with great loss of life and many injuries. The children had a wonderful time including being treated to a pantomime and tea with the Mayoress of Birmingham. For the most part though the hospital took care of patients with burnt or disfigured faces, particularly airmen, being treated by pioneering plastic surgeon Archibald McIndoe at East Grinstead.

The patients at Himley were not just severely burned but suffered great psychological trauma. The grounds of the hall were a safe environment for men afraid of being seen. Laura actively encouraged outings. Monday nights at the Dudley Hippodrome were reserved by managers Bob and Maurice Kennedy for wounded servicemen from nine local hospitals including Himley. It was not at all unusual for the men to be greeted by the smiling face of the Countess of Dudley. Many famous stars would also visit the hospitals and Gracie Fields, with her unpretentious style, proved a great hit at Himley.

Laura had a really good working relationship and friendship with the Mayor of Dudley for 1944, Arthur Hillman. He used to refer to her as 'Queen of the Midlands' or, in a reference to her old car, the Hillman Minx!

DID YOU KNOW?
During the English Civil War, Charles I and his Royalist army camped for one night in the grounds of what is now Himley Hall. The year was 1645 and he was soon to face defeat at the Battle of Naseby. According to Richard Symonds who accompanied the Royalist army 'one soldjer (sic) was hanged for mutiny' after trying to desert. Justice was swift in those days and the soldier was hanged from a suitable tree and buried in the grounds before the army departed.

Devil's Chariots

During the First World War something very secret was taking place in the Black Country. Under the guise of mobile water carriers, Britain had developed the world's first operational tank. The Mark 1, also known as 'Big Willie' or 'Mother', was built and tested at William Foster & Co. in Lincoln. It was quickly realised that a much larger production facility was needed, and this was the massive Metropolitan Carriage, Wagon & Finance Co. in Oldbury, who specialised in railway rolling stock. Next door was Mill Farm with fields which were ideal for the testing of these mighty machines. Oddly, it was the Royal Navy who were initially involved with the development of tanks through the Landships Committee of 1915, set up by First Lord of the Admiralty, Winston Churchill. Many people in Oldbury must have wondered why navy personnel were stationed so far from the sea. This was because No. 20 Squadron of the Royal Navy Air Service (RNAS), which had previously been involved in supervising the manufacture, testing and delivery of armoured cars had transferred over to tanks.

These early tanks were produced in male and female variants and given appropriate names. Male tanks were fitted with two 6-pounder naval guns fitted in projections called sponsons, one on each side. Female tanks were fitted with machine guns only. The main purpose of both types was to break through enemy lines. For the eight-man crew, both variants of the Mark I, 28-ton machines were cramped, noisy, fume filled, difficult to steer, and mechanically unreliable. Initially they met with little success apart from the fear factor. The Germans nicknamed the lumbering machines Devil's Chariots. Much more successful were the Mark IV version tanks used in the Battle of Cambrai in 1917. Many of these were built in the Black Country.

Not surprisingly, after the Battle of Cambrai, tanks captured the public imagination. It was quickly realised that they could be used to help sell War Bonds and War Savings Certificates. The idea of 'Tank Banks' was born where touring tanks would spend a week in a town raising money before moving on. They proved so popular that competition developed between towns to raise the most money. Tank Week in Dudley started on Monday 8 April 1918 when touring tank *Julian* arrived and was put on display in Stone

The commemorative tank in Hickman Park, Bilston. (Image reproduced with the permission of Wolverhampton Archives & Local Studies)

Street. An incredible £1 million was raised, helped by a contribution from industrialist and Alderman, George Bean on behalf of A. Harper, Sons & Bean Ltd.

After the war, many towns were presented with memorial tanks and Bilston acquired one in February 1920. The Mark IV tank was presented by Brigadier General T. E. Hickman and displayed in Hickman Park, named after his father Sir Alfred Hickman. Only seven Mark IV tanks are known to have survived. Bilston Council put its memorial tank up for sale to the highest bidder in 1923 'complete with engine'. It most likely went to a scrap merchant.

DID YOU KNOW?
The first air raid on the Black Country took place on 31 January 1916 when nine Zeppelins set out across the North Sea to raid Liverpool. Poor visibility and navigational errors meant that two of the airships, L21 and L19, arrived over the Black Country instead. First came L21 commanded by Max Dietrich, whose niece was the famous film star Marlene Dietrich. Bombs rained death and destruction on Tipton, Bradley, Wednesbury and Walsall. Later that same night the second Zeppelin arrived causing further serious damage.

Shell Corner

Anyone visiting Shell Corner following the early 1970s roadworks could be forgiven for wondering how the area acquired its rather odd name. About half a mile from Blackheath, but actually in Halesowen, Shell Corner is centred around the Long Lane junction with Nimmings Road. Prior to 1924 the island here was simply called The Junction. As a memorial to the terrible losses inflicted during the First World War, an 18-inch unexploded artillery shell was mounted on the island. From then on, the area became known as Shell Corner.

During the 1970s roadworks the shell was removed but never replaced by the council. The mystery of what happened to the artillery shell was eventually solved by the *Halesowen News* in 2016 when they reported that even though totally safe, the council had scrapped it apparently on the advice of an army bomb disposal squad! Shell Corner had lost its historic shell.

Following a campaign spearheaded by Dudley councillor Stuart Henley, a replacement artillery shell was donated by the British Army's Carver Barracks in Essex. The shell was painted by artists Cliff Collins and Colin Burchill of Halesowen College Art Department as a fitting memorial to the fallen in armed conflicts.

As a result of Stuart Henley's successful campaign, the replacement shell was installed in 2018 just a short distance from where the original was sited. A remembrance event involving the Royal British Legion now takes place on the Friday of remembrance weekend and the shell has become a focus for similar events throughout the year. Shell Corner once again has its iconic namesake.

Original First World War shell on Shell Corner. (Courtesy of the Black Country Museum)

The replacement decorated artillery shell. (Courtesy of Bryan Kelsey)

8. Would You Believe It?

Did Queen Victoria Name the Black Country?

A well-known and enduring local anecdote maintains that it was Queen Victoria who named the Black Country. The story, with slight variations, tells how she was passing through the area in her royal train. The industrial landscape horrified the Queen so much that she ordered a servant to close the carriage curtains on this 'awful black country'. Such is the story but there is some truth behind it.

It was not Queen Victoria but the thirteen-year-old Princess Victoria who was passing through the area in a horse-drawn carriage on her way to Wales in 1832. She would not be crowned Queen until 1837. Victoria kept a journal all her life and the first one was given to her by her mother, Princess Victoria of Saxe-Coburg-Saalfeld. Victoria wrote on the title page, 'This book, Mamma gave me, that I might write the journal of my journey to Wales in it'. On Thursday 2 August, her coach left The Bull's Head in Meriden and changed horses in Birmingham before heading off for Wolverhampton.

Rather than close the curtains of the carriage Victoria made some telling observations in her journal. On passing through 'a town where all coal mines are' she wrote that, 'The men, woemen (sic), children, country and houses are all black.' As they drove on, she noted that 'The country continues black, engines flaming, coals, in abundance, every where, smoking and burning coal heaps, intermingled with wretched huts and carts and little ragged children'. Victoria did not name the Black Country as such, but she certainly did use the words 'black' and 'country' in the same sentences if not actually together.

Young Queen Victoria in 1840. (Photo by Birmingham Museums Trust, licensed under CC0)

DID YOU KNOW?
The first known published reference to the Black Country appeared in the *Staffordshire Advertiser* on 27 November 1841. In a report entitled 'Reform Dinner at Lichfield' the town clerk, Mr Simpson, referred to 'what was called the *black country* in Staffordshire – Wolverhampton, Bilston, and Tipton' albeit with lower case letters. The earliest mention of 'Black Country' with capitals appeared in the book *Colton Green: A Tale of the Black Country, or a region of Mines and Forges in Staffordshire*, by the Revd William Gresley and published in 1846.

DID YOU KNOW?
Prince Albert's statue in Wolverhampton, known locally as the 'Man on the 'Oss', was unveiled in the presence of Queen Victoria herself in 1866. This was the Queen's first public engagement since the death of Prince Albert in 1861. Local legend has it that the designer Thomas Thornycroft committed suicide shortly after the unveiling because the crowd disapproved of the horse. In fact, Thornycroft died in 1885.

The Saddlers

In such an industrialised region how did Walsall come to gain a worldwide reputation for high-quality leather goods? The Black Country as a manufacturing area grew up around the abundant mineral resources found here. Coal, ironstone and limestone were used for smelting iron together with sand for casting. Brick clay for building and fireclay used in the glass industry were also found in the Black Country. While mining and metalworking were widespread, certain areas became notable for specialist trades such as Willenhall lock making and Stourbridge glass. What was it about Walsall that made it so prominent in the British leather industry and particularly in the making of saddlery?

Display of Lorinery made by John Edward Butler Limited of Walsall. (Courtesy of Michelle Darby)

Wendy Tipper demonstrating leather-working techniques at Walsall Leather Museum.

Doris Coxwell riding side saddle combining the skills of both loriner and saddler. (Courtesy of Sarah Bradbury)

The answer goes back to the Middle Ages with the loriners. They were attracted to the Walsall area for the mineral resources needed to forge the bits, buckles, spurs, stirrups, and other metal items needed for saddles and harness for horses. With loriners well established in the Walsall area, it made sense for leather workers to follow suit. By the early nineteenth century leather working was flourishing at a time when horses provided the main motive power. Working horses may have passed into history but the long tradition of fine leather working and saddlery lives on. The heritage of this is preserved at the Walsall Leather Museum.

Walsall Football Club is nicknamed the Saddlers. Established in 1888 by the amalgamation of Walsall Town and Walsall Swifts, they were known as Walsall Town Swifts. In 1896 they dropped Town Swifts from the club's name but kept the swift as an emblem. From the Swifts to the Saddlers, perhaps the nickname should really have been the Loriners.

Titanic Anchor and Chain

It is well known in the Black Country that the anchor and chain for the White Star liner *Titanic* was made at Noah Hingley & Sons in Netherton. It is not quite as straightforward as that for two reasons. Firstly, RMS *Titanic*, together with her sister ships the *Olympic* and *Britannic*, had three main bow anchors, not one. Secondly, the biggest of the three anchors, weighing in at just under 16 tons, was not on a chain at all but a substantial metal hawser, a wire rope made by Bullivant & Co. of London. As well as the massive centre anchor the *Titanic* also had two side anchors of just over 7.75 tons each. They were secured with cable chain manufactured by Hingleys. Cable chain is recognisable for the stay-pin or stud-link in the middle, which strengthens the chain and also helps prevent kinking and tangling.

Hingley's did not do all the construction work themselves on the Harland and Wolff order either. While they had an agreement to manufacture Hall's Patent Anchors, John Rogerson & Co. of Newcastle-upon-Tyne were contracted to cast the head while local Halesowen company Walter Somers Ltd forged the shank for the mighty centre anchor. Hingley's certainly manufactured many of the additional components and undertook final assembly of what was the world's largest anchor.

Stories and speculation abound around the *Titanic* and her sister ships. One concerns the naming of the third Olympic Class ship *Britannic*. The story goes that it was intended to be called the *Gigantic* but after the *Titanic* disaster the name was dropped in favour of Britannic. There was no real evidence for this until *Titanic* researcher Dr Paul Lee discovered documents in Dudley Archives concerning Noah Hingley & Sons referring to the anchors for the third ship. These documents do indeed refer to the *Gigantic*.

A team making ship's anchor chain.

Full-size replica of the Titanic anchor created for the Channel 4 series *Titanic: The Mission* in 2010. This replica is now on permanent display in Netherton.

DID YOU KNOW?
The last of the women hand chainmakers was Lucy Woodall. As a child she remembered the chain-making women's strike of 1910 and their leader Mary Macarthur. From the age of thirteen she had spent a lifetime in the chain shop, only retiring in 1969. Even then, she returned to work part-time up until 1973. Lucy died in 1979 just shy of her eightieth birthday. The last small chain shop in its original location is at Mushroom Green, near Cradley Heath, where regular demonstrations of hand chain making are given.

Cavalcade of Heavy Horses

Did it really take twenty heavy horses to pull the near 16-ton *Titanic* centre anchor? Well, there are certainly photographs showing this to be the case, but the pictures do not necessarily tell the whole story. While the total number of twenty is not in dispute there are differing accounts as to why there were so many. The number of horses required to pull any particular load would be calculated beforehand. A typical heavy horse weighing anything up to a ton itself could pull about 2 tons on a wheeled cart. However, two such horses used to working in tandem could pull a load not of four tons but around six. Teams

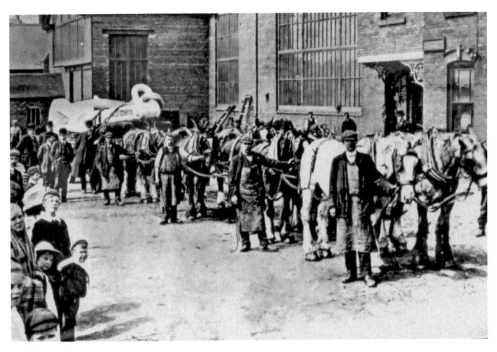

The eight Hingley horses and the Titanic anchor. (From the collection of the late Ron Moss)

of eight horses were common and even twelve but certainly not twenty! Not only that, eight good heavy horses could easily pull a dray and a 16-ton load.

The dray that arrived from the London & North Western Railway (LNWR) goods station in Dudley, near where the Black Country Living Museum is now, came with twelve Clydesdale horses to pull the anchor. The late Ron Moss in his definitive book *Chain & Anchor Making in the Black Country* describes talking to Hingley employees who were present on the day. They recalled how a member of the Hingley family called the supplied horses 'poor specimens' and ordered eight of their own horses to be attached as they would 'handle it easily'. The Hingley family were renowned for taking great pride in their team of heavy horses. Of course, the twelve that arrived with the dray had to be returned to where they came from and so were simply attached in front of the Hingley horses. The cavalcade of twenty heavy horses hauling the *Titanic* anchor has since passed into Black Country legend.

Dambusters

The former Netherton ironworks of M. & W. Grazebrook has become associated with making the castings for the 'bouncing bombs', made famous by the Operation Chastise (Dambusters) raid. The bombs needed to destroy the German dams were the brainchild of inventor Barnes Wallace. He was a chief engineer for Armstrong-Vickers and records show that the Vickers Type 464 Upkeep Mine (bouncing bomb) was produced at their fabrication facility in Barrow with no mention of any Black Country connection.

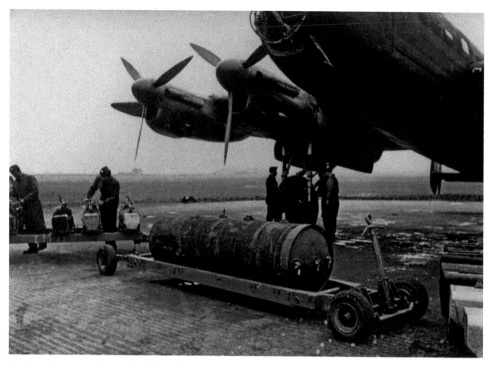

An Avro Lancaster being loaded with a 'Blockbuster' bomb. (Contributor: Alamy Stock Photos)

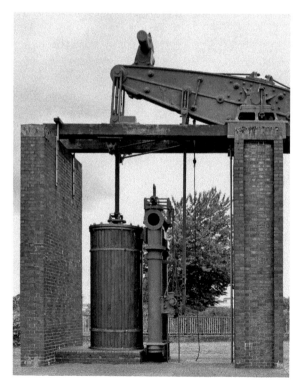

The massive blast furnace steam-blowing engine from Grazebrooks now situated on Dartmouth Circus, Birmingham.

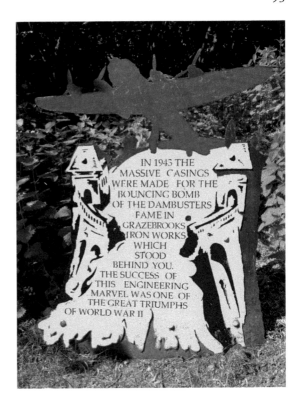

Grazebrooks and 617 Squadron commemorated on the Dudley No. 2 Canal sculpture trail.

Right from the start of the Second World War though Grazebrook's Iron Works was contracted by the Ministry of Aircraft Production to manufacture large, specialist bombs. They produced 4,000 lb, 8,000 Ib and finally 12,000 lb High Capacity (HC) bombs for Bomber Command. The RAF nicknamed these 'cookies', but the press came up with the name 'Blockbusters'. They were not designed by Barnes Wallis but by local man Alfred Cecil Brooks. He was born in Amblecote, Stourbridge, but his work was so top secret that when he was awarded the MBE in 1944 it was for 'Outstanding services of a nature that cannot be revealed'. The connection with the famous 'Dambusters' squadron seems to be that the larger blockbuster bombs could only be carried by Lancasters with modified bomb doors, such as those flown by 617 Squadron, but not used on the raid against the German dams.

At least two local RAF men were connected with 617 Squadron. Dudley-born Stephen Burns was a rear gunner during the Dambuster's raid, but his plane had to turn back to base after sustaining damage when if flew too low over the sea and lost its Upkeep Mine. In December 1943, his plane was shot down and Stephen Burns together with the rest of the crew were laid to rest in Belgium. Lawrence (Larry) Curtis joined 617 Squadron as a replacement for crew lost on the Dambuster's raid. As a radio officer with the rank of Squadron Leader, Larry Curtis had a distinguished career with the RAF, winning no less the two Distinguished Flying Crosses and surviving over seventy bombing missions. He took part in raids on U-boat pens, V-1 rocket bases and the German battleship *Turpitz*. One of his first missions with 617 Squadron was to attack the heavily defended Dortmund-Ems Canal with 12,000 Ib HC bombs. Bombs that may well have been made in Netherton by Grazebrooks.

Wyatt Earp and Walsall

Another well-known local 'fact' is that Wyatt Earp, or at least his family, hailed from Walsall. Not only that, but they were saddle makers, which of course Walsall is renowned for, and naturally found plenty of work in America's Wild West. The Earp name is found around the Walsall area, but if there are any family connections with the legendary lawman then then it will be from the American side of the family, not the other way around.

Wyatt Berry Stapp Earp, to give his full name, was born in Monmouth, Illinois. His parents Nicholas and Virginia Earp were also born and raised in America. Indeed, the Earp family in America can be traced right back to 1656 when Thomas Marion Earp (Harp) Jr was born in County Armagh, Northern Ireland. He emigrated to what is now the Baltimore area of America as an indentured servant in the seventeenth century. It is likely that the name Earp is simply a corruption of Harp as both names appear in the records.

Wyatt Earp at various times straddled both sides of the law and involved himself with brothels, saloons and gambling, as well as being a lawman. His legendary status is partly thanks to the biography written by Stuart N. Lake in 1931, numerous books, films and, of course, the famous gunfight at the O. K. Corral. It took place on 26 October 1881 in Tombstone, Arizona. A running feud between the Earp brothers and a band of outlaws called the 'cowboys' resulted in bloodshed.

Town marshal Virgil Earp with deputy's Wyatt and Morgan Earp, together with their gambler friend Doc Holliday, faced off against Ike Clanton and five cowboys. In a gunfight said to have lasted less than a minute Ike Clanton and two cowboys ran from the fight but Ike's brother Billy together with Tom and Frank McLaury lay dead. The Earps and Doc Holliday survived, but Wyatt was the only one to escape unscathed. The gunfight did nothing to end the feud but would eventually help create the legend of Wyatt Earp.

Whether Wyatt Earp's legendary status is deserved or not, when the Earp brothers and Doc Holliday faced Ike Clanton's cowboys for the famous shootout, none of them would have been speaking in Black Country dialect!

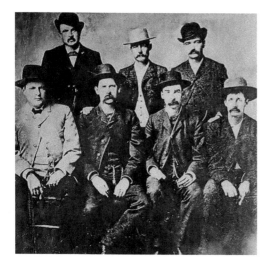

Dodge City Peace Commissioners. Wyatt Earp is third from the left. (From the National Archives of the United States)

Acknowledgements

I am grateful to the many people and organisations who provided information, images, and inspiration in the production of this book. Many are mentioned throughout the text, but special thanks are due to:

Black Country Living Museum
Black Country Muse website and Dennis Neale
Black Country Society, Keith Hodgkins, Pete Glews and the late Ron Moss
Eliza Tinsley Ltd, Sheila Chamberlain-Hyett and Steve Hyett
Lichfield Waterworks Trust and Alan Hill
Sedgley History Society website and George Blackham
Sedgleyhistory.com website and Ian Beach
Shropshire Star and *Pictures From the Past* Editor Toby Neal
Stourbridge.com website
Yorkshire-aircraft.co.uk website and Richard Allenby

Bryan Kelsey
Carol Davies
Chris Turton
Colin MacDonald
Dave Holloway
Dave Marsh
David Harrison
Dennis Fox
Diane Homer
Dr Paul Lee
Gregory Dunn
Jayne Harris
Joe Bourne

Kevin Goodman
Louise small
Michelle Darby
Ned Williams
Paul Balluff
Phil Cervi
Rob Grazebrook
Sarah Bradbury
Stella Job
Steve Field
Steve Willis
Stuart Henley
Tony Hisgett

About the Author

Andrew Homer has written several books on the Black Country and Birmingham and has an MA in West Midlands History awarded by the University of Birmingham. He was also Secretary of the Black Country Society before retiring to Devon. Andrew presents lectures to various organisations and has appeared on regional and national television. After a career as a college lecturer, he worked as a historic character at the Black Country Living Museum and could be found explaining the history of the region and telling the stories of the people who helped forge our industrial and social heritage.